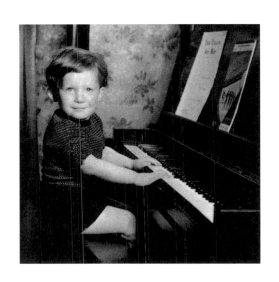

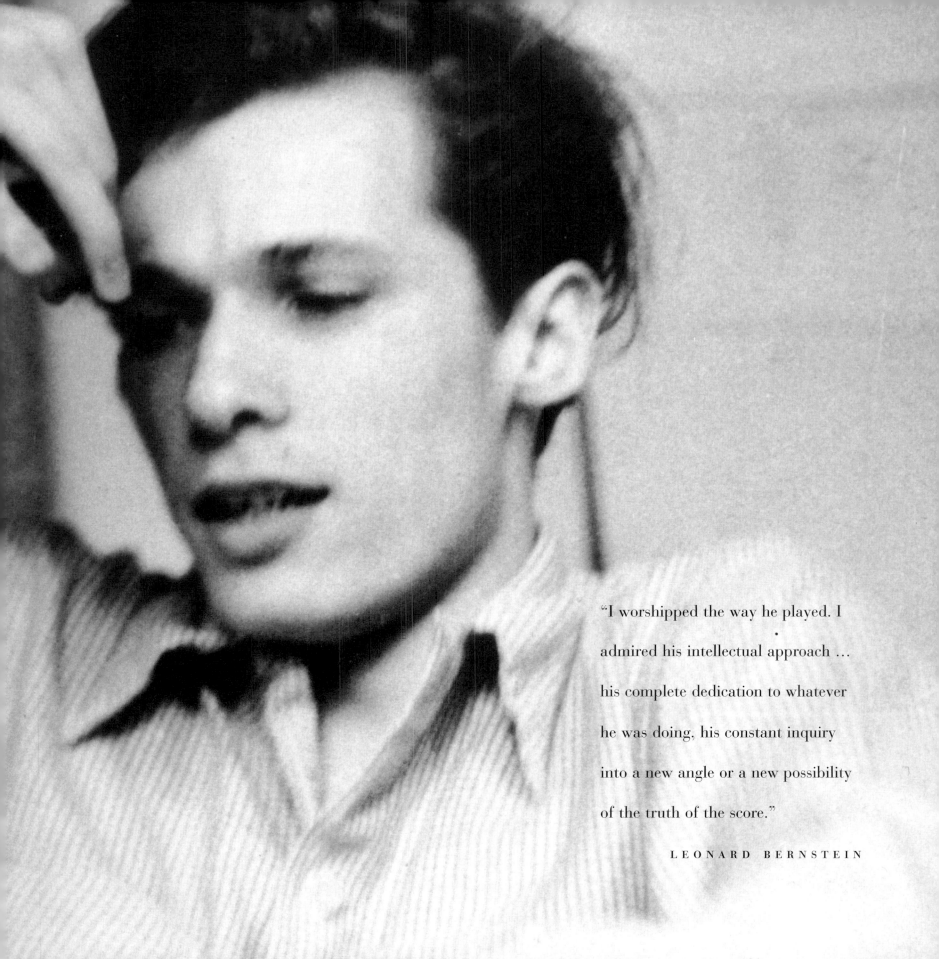

"I worshipped the way he played. I
admired his intellectual approach …
his complete dedication to whatever
he was doing, his constant inquiry
into a new angle or a new possibility
of the truth of the score."

LEONARD BERNSTEIN

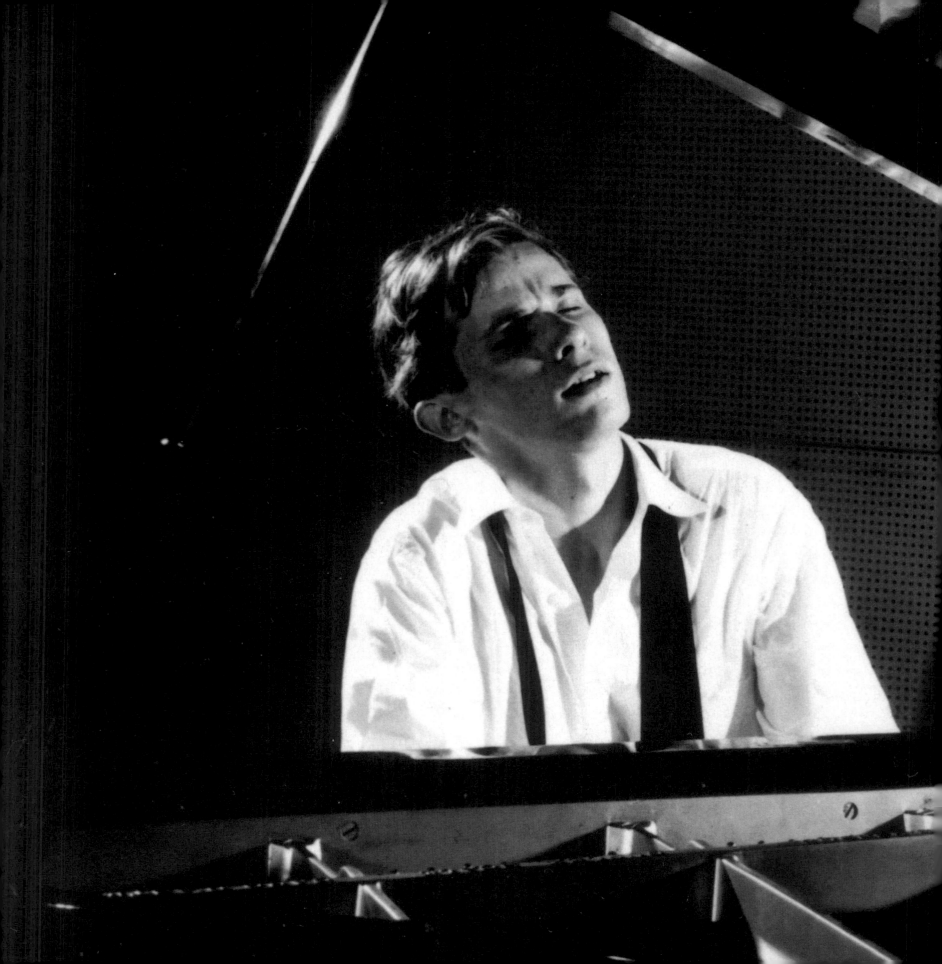

"A merging of self with the innerness of the music."

GEOFFREY PAYZANT

"For every hour you spend in the company of other human beings you need X number of hours alone . . . isolation is the indispensable component of human happiness."

GLENN GOULD

GLENN GOULD A LIFE IN PICTURES

Foreword by Yo-Yo Ma

Introduction by Tim Page

DOUBLEDAY CANADA

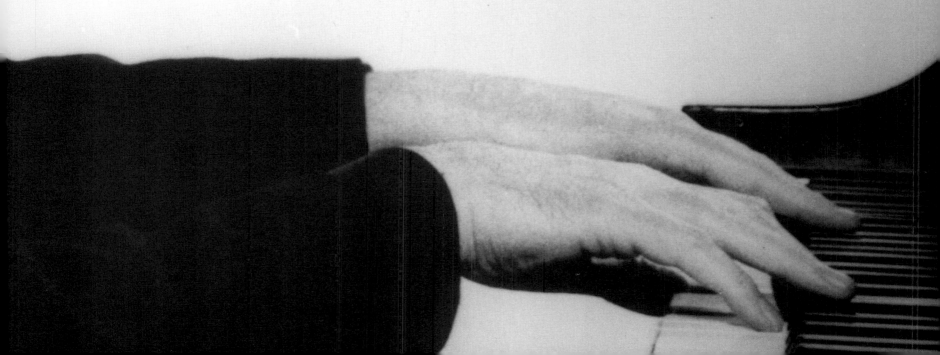

GLENN GOULD (in a child's handwriting)

Glenn practises his signature, age five or six.

(OPPOSITE) Released in 1959, this Columbia recording featured the music of Berg, Krenek and Schoenberg.

Copyright © Estate of Glenn Gould and Glenn Gould Limited 2002

All rights reserved. The use of any part of this publication, reproduced, transmitted in any form or by any means electronic, mechanical, photocopying, recording or otherwise, or stored in a retrieval system without the prior written consent of the publisher—or, in the case of photocopying or other reprographic copying, a license from the Canadian Copyright Licensing Agency—is an infringement of the copyright law.

Doubleday Canada and colophon are trademarks.

National Library of Canada Cataloguing in Publication Data

Main entry under title:
 Glenn Gould : a life in pictures / introduction by Tim Page; foreword by Yo-Yo Ma.

ISBN 0-385-65903-2

1. Gould, Glenn, 1932–1982—Pictorial works. 2. Pianists—Canada—Pictorial works.

ML88.G696G555 2002 786.2'092 C2002-901553-7

Jacket images: Courtesy of the Estate of Glenn Gould
Printed and bound in Canada

Published in Canada by
Doubleday Canada, a division of
Random House of Canada Limited

Visit Random House of Canada Limited's website: www.randomhouse.ca

FRI 10 9 8 7 6 5 4 3 2 1

CONTENTS

FOREWORD

Yo-Yo Ma

One of Glenn Gould's greatest gifts was his ability to create breathtaking new sound worlds from his own deep understanding of the abstract. In his recordings, writings and documentaries, Gould effortlessly transformed and reduced concepts of vast complexity into forms of profound beauty and simplicity.

Gould's mind was a brilliant and shimmering prism through which sounds, senses and ideas were magically transfigured. As a teenager hearing his 1955 CBS recording of the Bach *Goldberg Variations* for the first time, I experienced a musical epiphany that would fuel my musical thinking for years to come. His recordings were a touchstone during those early years, and I admit that a copy of the *Goldberg* LP was prominently displayed on the wall of my freshman dorm room.

Gould was not a tactile or experiential thinker; rather, he dwelt deeply within the recesses of his own interior world. And in fact, he insulated himself from the realities of the physical world by creating his own self-sustaining universe. My wife, Jill, recalled how she encountered Gould for the first time in 1972, the same summer she and I met at the Marlboro Music Festival in Vermont. On a sunny, hot and cloudless morning, there he stood in cap, heavy winter coat, galoshes and gloves asking to interview Pablo Casals—it was a sight she would never forget!

Gould constructed a series of elegant hypotheses to define the natural world around him. He approached life with the wonder and curiosity of a scientist, and in this respect, he reminded me of the great physicist Richard Feynman. While Feynman sought to study nature, which guarded its secrets, Gould's approach was one step removed. Gould used the natural world as a backdrop to drive his imagination, yet did not require any proof or evidence of its actual existence. One of my favourite stories about Gould occurred when he was on tour in Israel in the 1950s. Disheartened by the piano in the hall, he drove his car out to the sand dunes near Tel Aviv and imagined he was playing his boyhood piano in his cottage on Lake Simcoe. He fixed his gaze on the Mediterranean and practised for hours—and that evening performed Beethoven's Piano Concerto No. 2 to stunning and powerful effect.

Indeed, Gould exemplified how the mind could transport one to the outer reaches of creative expression. In his groundbreaking radio documentary *The Idea of North*, he

explored the romantic ideal of the North, as a geographic region and as a mindset. The program consisted of a series of interviews featuring Canadians living in the arctic and subarctic regions of Canada who were asked to define the ineffable ideal of what constituted "the North." The result was an elaborate, fugal tapestry consisting of interviews that were edited by Gould himself. Well-known for his fear of the cold, the reclusive artist ventured no farther north than Winnipeg and Churchill. "I have no real experience of the North. I have remained of necessity an outsider," he admitted. "The North has remained for me a convenient place to dream about, spin tall tales about, and in the end avoid."

Imagined experience is perhaps made richer by the mind's eye, and this divide between imagined experience and reality can be found in the lives of so many of the great artists. Like Ravel, who infused his works with the bell-like pentatonicism of the Javanese gamelan orchestra, which he heard for the first time at the 1889 World's Fair in Paris, Gould shared a penchant for exploring new sound worlds. The fact that Ravel never travelled to the East and that Gould never travelled to the North is perhaps immaterial. It was "the idea of" these worlds that ignited their creative imaginations.

Shortly after Gould completed *The Idea of North*, he was asked to do a radio documentary about China. He was fascinated with the idea, but proposed to do the documentary without leaving Canada. "The prospects for a visit by me to the Orient are nil." Yet even his fear of flying could not curb his longing to explore this vast new territory. He suggested doing a radio essay on the theme of solitude with China as the backdrop. Not surprisingly, Gould never went East. Yet he remained devoted to exploring new frontiers.

Creativity cannot be measured by the boundaries of north, south, east or west. Gould once defined art as "the gradual, lifelong construction of a state of wonder and serenity." He understood the great joy of being able to transform a pure abstract concept into a thing of tangible beauty. His work reflects a birth of sorts, and was a wondrous passport to his mind and spirit.

While we are bereft of Gould's inimitable artistry, the legacy of his imagination is a gift we will continue to treasure for many years to come.

INTRODUCTION

A State of Wonder

Tim Page

It is almost four decades since Glenn Gould gave his last public recital, took his bows and disappeared into the privacy of the recording studio. As this book goes to press, even the youngest of those listeners fortunate enough to have heard Gould in concert will have settled into middle age, and the pianist himself, had he lived, would now be entering his seventies.

Glenn Gould was blessed with a multitude of gifts, but longevity was not among them. As the world knows, he died of a stroke in Toronto General Hospital on October 4, 1982, barely a week after his fiftieth birthday. And yet, if Gould could not cheat the grave, he has, in some profound and personal way, transcended time, for he remains a vital—indeed *essential*—musical presence all these years later, in some ways more central to our experience now than when he was alive.

Gould's many recordings continue to sell steadily; his life, performances and philosophies have been examined in at least a dozen volumes; he has been the subject of a bizarre novel (Thomas Bernhard's *The Loser*) and a full-length feature film. The Internet is filled with sites devoted to him, ranging from official repositories (such as the Glenn Gould Collection at the National Library of Canada) to idiosyncratic—and often deeply touching—private homages. And any new pianistic interpretation of the music of Johann Sebastian Bach is bound to be evaluated, at least in part, by comparison to Gould's.

Why does Gould continue to exert such fascination? There are many reasons, the first, simplest, most important and most obvious of which is the fact that he was a very great musician. By "great," I mean that he was able to find new depths—and sometimes entirely new *surfaces*—in thrice-familiar masterworks. While Gould knew no technical difficulties (has anybody ever possessed ten fingers with ten such marvellously independent lives?), there was always something more than mere virtuosity in his playing. No matter how one chooses to define that extra, *ur*-Gouldian dimension— as expressive urgency, brainy intensity, spiritual seeking, nervous energy or some combination of all these and more—it was ever present in his best performances, which could have been by no other artist.

Moreover, his ideas about music, however outrageous or wrongheaded they could seem, were boldly original; even his detractors would generally acknowledge that Gould thought for himself. For example, he avoided the music of Chopin, Schubert, Schumann, Liszt and Debussy—"I have always felt that the whole centre core of the piano recital repertoire is a colossal waste of time," he told me in 1980—and extolled the work of Arnold Schoenberg, Paul Hindemith and Ernst Krenek. He applied a form of musical deconstruction to the late Mozart sonatas, playing them as if he hated them (which, as it happened, he did). But his most controversial moment came when he withdrew from live perform-ance and devoted all of his energies to recordings and film, from discs of the standard repertoire (done up, most often, in decidedly non-standard fashion) to his own unique radio docudramas such as *The Idea of North.*

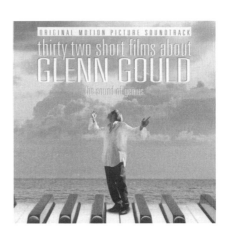

In some ways, it was Gould's physical inaccessibility during the last eighteen years of his life that codified his legend as remote, austere poet and pilgrim of the North (the "Idea of Gould," as it were). For many, it was as if he had been frozen in time and some-how remained the extraordinary-looking young man, ethereally beautiful rather than traditionally handsome, who had adorned the jackets of his early recordings. Gould was not unaware of his mystique: "My policy has long been to cut the cloth to fit the corner newsstand," he said. And he cultivated his persona so successfully that a large number of the images in the film *Thirty-two Short Films about Glenn Gould* were taken directly from the album covers he selected so carefully. Nevertheless, his isolation was genuine, pervasive and sometimes difficult to bear.

Gould was paradoxical in the extreme, and almost any statement one makes about him can be contradicted by another that is equally valid. He made some of the best recordings of his time and (as he himself admitted) a few of the worst. He lived a life of monklike austerity, yet he was one of the jolliest and most spontaneous telephone companions imaginable. He was an individualist who prized rectitude and puritanical

Colm Feore is the actor playing Gould on the soundtrack album for *Thirty-two Short Films about Glenn Gould.* The thirty-two films allude to the *Goldberg Variations.*

moral values, yet he considered himself a socialist and was skeptical of religious dogma. He frowned upon alcohol as weakness and indulgence, yet relied upon the generous consumption of tranquilizers. He loathed ostentatious Romantic effusion, yet esteemed Richard Strauss as the greatest of twentieth-century composers. He was reclusive and retiring, yet he wanted to be heard, be seen, be felt everywhere.

And so he is.

"Yonge Street doesn't exactly end; it just sort of dissolves into the Ontario highway system, and it is possible to follow this road, north and west, for about 1,200 miles. Most of those miles traverse country that is absolutely haunting in its emptiness and bleakness and starkly magnificent beauty."

GLENN GOULD

The critic and translator Andrew Porter once suggested that it was possible to fully comprehend Richard Wagner's *Ring* cycle only after gazing long and deeply into the River Rhine. Likewise, I believe that the experience of a December afternoon in Ontario, watching a smear of winter sun briefly illumine a sky of battleship grey, can provide considerable insight into the character of Glenn Gould. This was his chosen environment, the place and the weather that he loved best. "My moods bear an inverse relationship to the degree of sunlight on any given day," he said. "'Behind every silver lining, there's a cloud,' I tell myself when things threaten to get too bright."

Gould was born in Toronto on September 25, 1932, during the worst year of the Great Depression, when up to a quarter of the city's population was unemployed. By the standards of the time, Bert Gould, an established furrier, and Florence Greig Gould, his music teacher wife, were modestly affluent. They lived in a comfortable home at 32 Southwood Drive in an area east of downtown known as the Beach. The journalist Robert Fulford, who grew up next door to the Goulds, has left a vivid picture of the neighbourhood: "It was more village than city, a self-contained world where just about everyone came from British or Irish stock, and most people agreed that the Empire would last forever. A half-hour streetcar ride connected us to the core of Toronto and those who had jobs went there every day; otherwise, Beach people kept to themselves. We had everything we needed —schools, churches, stores, movie houses, even a little library. Above all we had the beach itself, a mile-long strip of sand on Lake Ontario, and more parkland than a child could ever explore."

Looking back half a century later, Bert Gould described the birth of his only child as "an answer to prayer." Florence Gould was then almost forty-one, and she had previously suffered several miscarriages. Glenn's musical talent was apparent almost immediately. "As soon as he was old enough to be held on his grandmother's knee at the piano, he would never pound the keyboard as most children will with the whole hand, striking a number of keys at a time," his father wrote in a brief, unpublished memoir. "Instead, he would always insist upon pressing down a single key and holding it down until the resulting sound had completely died away. The fading vibration entirely fascinated him."

A Mother's Day card made by Glenn when he was seven or eight.

At the age of three, Gould began piano lessons with his mother. He was gifted with absolute pitch and learned to read music before he could read words. By the time he was five, he was writing his own songs and playing them before church groups. And

then, when he was six years old, he was taken to hear the fabled pianist (and ex-prodigy) Josef Hofmann. "It was, I think, his last performance in Toronto," Gould later said, "and it made a staggering impression. The only thing I can really remember is that, when I was being brought home in the car, I was in that wonderful state of half-awakeness in which you hear all sorts of incredible sounds going through your mind. They were all *orchestral* sounds, but I was playing them all, and suddenly I was Hofmann. I was enchanted."

From then on, Gould was determined to become a pianist. His mother encouraged his ambition, practising with him every day until he was ten and then entrusting his development to the care of Alberto Guerrero, a mid-fifties Chilean-born pianist with a strong modernist bent who played the first Toronto performances of works by Schoenberg, Stravinsky and Hindemith.

"He was not so much a teacher of piano as a teacher of *music*," the composer John Beckwith, another Guerrero pupil, recalled. "He had a view of music as a profoundly serious commitment, and he somehow got you to keep this in mind while he helped you through your sometimes-unseemly physical and mental grapplings with the notes." Although Gould would later claim that he was mostly self-taught, Guerrero clearly had an influence on his brilliant charge. Beckwith observed that both men sat lower in relation to the keyboard and played with flatter fingers than most pianists; moreover, Guerrero's "performances of light rapid passages had not only fluency and great speed but also

exceptional clarity and separation of individual notes"—qualities that would become paramount in Gould's own music making.

Gould had come to Guerrero through the recommendation of Sir Ernest MacMillan, the conductor of the Toronto Symphony Orchestra and the director of what is now known as the Royal Conservatory of Music. Since its incorporation as the Toronto Conservatory of Music in 1886 by Edward Fisher, the school has helped shape the artistry of generations of Canadian musicians (among them Jon Vickers, Lois Marshall and Teresa Stratas) and it remains the most prestigious institution of its kind in Canada. Gould began his lessons at the conservatory in 1942; over the next four years, he studied theory with Leo Smith and organ with Frederick C. Silvester.

"The organ was a great, great influence, not only on my later taste in repertoire, but I think also on the physical manner in which I tried to play the piano," he said. By the time Gould was twelve, he could play the first book of Bach's *Well-Tempered Clavier* from memory. He won virtually every prize the conservatory had to offer him, and graduated, with highest honours, at the age of fourteen.

Prodigies stand apart and they know it. This must be one of the reasons so many precocious children have a love for the mysterious and fantastic. (In Gould's case, this manifested itself in an opera libretto he wrote when he was twelve, concerning the self-destruction of the human race and Earth's subsequent revitalization by members of the animal kingdom.) Such children "understand" aliens, for from an early age they are acutely aware of their own difference, their "specialness." The intense dedication they bring to their calling (for such it is, rather than any sort of conscious "choice") necessitates a temperamental separation from their peers. In later life, Gould used to say that he was "in" the world but not "of" it; this perception, with all of its ramifications, dated from earliest childhood.

The cover and title page of Glenn's first piano book.

And so the boy who was capable of dazzling professional musicians by sight-reading any score and memorizing it on the spot was pilloried, again and again, for his inability to play sports, his adult (and highly specialized) intellectual preoccupations and his general lack of interest in the day-to-day business of being a child. Such strangeness ensures a certain loneliness, and Gould's best friends were his animals—a setter named Nick, a bird called Mozart and a distinguished quartet of goldfish: Bach, Haydn, Beethoven and Chopin—whom he endowed with human characteristics.

Animals, of course, cannot talk back, and Gould's predilection for controlling his friendships was already beginning to manifest itself. His friend Peter Ostwald wrote, "Glenn always sought to create an impression of fierce independence, of being some-one for whom human interaction and intimacy were totally inessential. In actuality, he craved contact—always on his own terms, of course—and he often succeeded in drawing someone into his orbit, as he did later with me. His remarkable charm, playfulness and intellect attracted people, and he reveled in the attention they were willing to give him so long as he remained in control and everything went the way he wanted it to go."

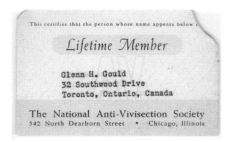

Gould grew increasingly nervous and unhappy as he entered his teens; much of the anxiety may have been due to the simultane-ous launch of his professional career. This has been variously dated to December 12, 1945 (when he played Bach, Mendelssohn and Dupuis on the organ in Toronto's Eaton Auditorium), May 8, 1946 (the first movement of Beethoven's Piano Concerto No. 4 at Massey Hall with the Toronto Conservatory Orchestra) or January 14, 1947 (when he played the same concerto in its entirety with the Toronto Symphony Orchestra, under the direction of Bernard Heinze).

A critique of this last concert, published in the Toronto *Globe and Mail* the following morning, acknowledged Gould's brilliance, yet voiced what would become familiar concerns about his stage presence. "Unfortunately, the young artist showed some incipient mannerisms and limited his self-control to the periods when he himself was playing," the anonymous reporter wrote. "As he approaches adult status, he will undoubtedly learn to suppress this disturbing fidgeting while his collaborators are at work."

He never did. Still, by the time Gould was fourteen, he was something of a legend in local musical circles, and Walter Homburger, the manager of the Toronto Symphony and one of the leading presenters of classical music in the nation, agreed to take him on as a fledgling artist. Most of Gould's early performances were in the Toronto area, with the occasional venture to Hamilton or London, Ontario. But on December 24, 1950, he was heard all across Canada, and his life was changed forever.

On that Sunday morning, Gould's playing of sonatas by Mozart and Hindemith was transmitted live by the Canadian Broadcasting Corporation. The occasion, he recalled, was a memorable one: "I discovered that in the privacy, the solitude and (if all Freudians will stand clear) the womb-like security of the studio, it was possible to make music in a more direct, more personal manner than any concert hall would ever permit. I fell in love with broadcasting that day and I have not since then been able to think of the potential of music (or, for that matter, of my own potential as a musician) without some reference to the limitless possibilities of the broadcasting and/or recording medium. For me, the microphone has never been that hostile, clinical, inspiration-sapping analyst that some critics, fearing it, complain about. That day in 1950, it became, and has remained, a friend."

Gould's love of animals led him to join the National Anti-Vivisection Society while still a teenager. A major bequest in his will was to the Toronto Humane Society.

Three years later, Gould made his first commercial record—a ten-inch LP on the Hallmark label, featuring a performance of Alban Berg's Piano Sonata, opus 1, and three duets with the Canadian violinist Albert Pratz. Over the next few years, he buttressed his reputation in Canada, continuing to appear on the CBC—a chastely classical performance of Beethoven's Concerto No. 2 in B-flat (always Gould's favourite

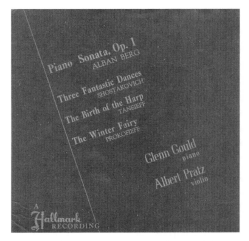

of the five) with MacMillan and the Toronto Symphony has been preserved—and playing and lecturing in two concerts of music by Berg, Schoenberg and Anton Webern, concerts that he annotated and co-produced with Robert Fulford. The two men had called their organization New Music Associates. For their third offering, Gould suggested an all-Bach program.

"But, Glenn, if we are 'New' Music Associates, why are we doing a Bach concert?" Fulford asked his friend.

"Bach is ever new," came the reply.

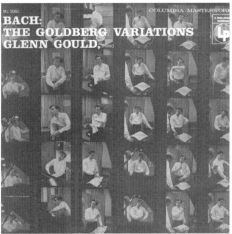

Gould had begun to establish himself as a thrilling and persuasive artist with a keenly individual mind. When it came time to make his American debut—at the Phillips Gallery in Washington, D.C., on January 2, 1955, with a repeat performance at Manhattan's Town Hall the following week— he selected music by Orlando Gibbons, Jan Sweelinck, Berg, Webern, Beethoven and Bach. It was an uncompromising program by anybody's measure and all but unprecedented as a first offering from a pianist of twenty-two who was still unknown in the United States.

As it happened, the program was also spectacularly effective. "Few pianists play the piano so beautifully, so lovingly, so musicianly in manner and with such regard for its real nature and its enormous literature," Paul Hume wrote in the *Washington Post*. "Glenn Gould is a pianist with rare gifts for the world. It must not long delay hearing and according him the honor and audience he deserves. We know of no pianist anything like him of any age."

Neither did David Oppenheim, the director of Columbia Masterworks (later Sony Classical), which was then one of the two largest American record companies. Oppenheim promptly signed Gould to an exclusive contract on the morning after his New York appearance. It was decided that the pianist's first recording for the label would be J.S. Bach's "Aria mit verschiedenen Veränderungen" ("Aria with Different Variations"), now universally known as the *Goldberg Variations*. It was an audacious choice, for many reasons, and it is not surprising that some executives at Columbia felt a certain apprehension about Gould's choice of repertoire.

Some historical perspective may be in order. In the mid-1950s, there were two distinctly different ways of playing Bach's keyboard works that were considered more or less within the realm of respectability. The movement toward musicological "authenticity" in Baroque performance was beginning to gain momentum, and a number of influential players, pedagogues and critics had declared Bach absolutely off-limits to the piano. In the aurorean future, they asserted, this music would be heard only on the harpsichord and clavichord, and Bach pianism would go the way of many another Victorian relic. Meanwhile, a number of fine musicians, unperturbed, went on playing Bach on their Steinways and Bösendorfers, as they always had. But it was usually a romanticized Bach—poetic, luminous, with an emphasis on harmonic unity rather than contrapuntal interplay, and a sound heavily suffused by the damper pedal.

(TOP) Cover of Gould's first commercial recording, released in 1953. (BOTTOM) Cover of Gould's breakthrough recording of Bach's *Goldberg Variations*, released by Columbia in 1956.

Window display at Simpson's department store, Toronto, just after the release of the *Goldberg Variations* in 1956.

Gould's first recording of the *Goldbergs* heralded a new approach to Bach—one that combined the stark, separate contrapuntal voicings so easily delineated on the harpsichord with the tonal colour and dynamic calibration available from the modern piano. Never before had the composer's music been played with such dazzling and incisive virtuosity.* Yet underlying the technical flamboyance was evidence of a remarkable cerebral intensity.

It was possible to dispute Gould's way with Bach (and many people did); it was even possible to dislike it. But there was no way to ignore the fact that he had tapped into a fresh, original and—for most of his listeners—vastly appealing way of interpreting a composer who, at that point, was still probably more revered than he was loved. To be sure, there had been some admirable earlier recordings of the *Goldbergs* (by Wanda Landowska and Rosalyn Tureck on the harpsichord and Edwin Fischer on the piano, among others), but it was generally considered an austere, recondite and semi-scholarly work better suited to theoretical analysis than to listening pleasure.

But Gould knew what he was doing—as he so often did—and the recording was an immediate popular and critical success. It has never gone out of print, with the result that it has now graced the catalogue for almost half a century. It was also one of those rare classical recordings that were considered bona fide intellectual *events* by the public at large. If you were young in the 1950s, and you attended the films of Ingmar Bergman, struggled your way through William Gaddis's *The Recognitions*, read your Sartre and Camus and followed the daunting stylistic twists and turns from Miles Davis and other modern jazz artists, it was more than likely that you were a Gould fan as well.

* The only earlier Bach recording that sounds remotely "Gouldian" in its clarity, brilliance and fierce linear concentration is one of the Partita No. 4 by the American pianist William Kapell, left incomplete when he was killed in a 1953 plane crash. Two years earlier, Kapell had played the work in Toronto and Guerrero reviewed the concert for the *Globe and Mail*. It is therefore at least possible that Gould may have been influenced by this great contemporary, with whom he had little else in common.

The boy from the Beach was suddenly a star of the first magnitude, with a best-selling record, a full calendar of prestigious appearances stretching several years into the future, a magnificent twenty-six-room home on the outskirts of Toronto and devoted fans around the world. In 1957, he became the first Canadian artist to perform in the Soviet Union (where he played to rapturous acclaim in Moscow and Leningrad) before heading westward again to make his debut with the Berlin Philharmonic Orchestra under Herbert von Karajan, the so-called General Music Director of Europe, who was then at the height of his influence. By any standards, Gould had *arrived.*

It was, he would later recall, the worst time of his life.

Gould felt imprisoned by fame. From the beginning, he hated live performances. Now, with his sudden celebrity, he was in a position to discover that he also hated touring, hated airplane travel, hated post-concert receptions with their requisite unstructured social chit-chat, hated the extramusical hysteria that accompanied him everywhere. "At concerts, I feel demeaned," he complained, "like a vaudevillian."

And, indeed, the public had been conditioned to expect a "show" of sorts from Glenn Gould. He had a penchant for singing along—loudly—as he played. He favoured a very low seating, travelling with his own folding chair that set him at about eye level with the keyboard. He wore heavy coats throughout the summer—"I have an absolute horror of catching cold," he explained—and would sometimes perform in fingerless gloves. And he clearly had no interest in traditional stage decorum; his body shuddered and contorted at the keyboard while his expressive face, suffering and ecstatic, seemed to embody the essence of music in all its pain and exaltation.

Columbia Masterworks played up these "kooky" qualities in a press release issued with the *Goldberg Variations* that purported to describe the recording sessions: "It was a balmy June day, but Gould arrived in coat, beret, muffler and gloves. 'Equipment' consisted of the customary music portfolio, also a batch of towels, two large bottles of spring water, five small bottles of pills (all different colors and prescriptions) and his own special piano chair. Towels, it developed, were needed in plenty because Gould soaks his arms and hands up to the elbows in hot water for twenty minutes before sitting down at the keyboard. . . . Bottled spring water was a necessity because Glenn can't abide New York tap water. Pills were for any number of reasons—headaches, relieving tension, maintaining circulation."

YOUR COOPERATION WILL BE APPRECIATED

A pianist's hands are sometimes injured in ways which cannot be predicted. Needless to say, this could be quite serious.

Therefore - I will very much appreciate it if handshaking can be avoided. This will eliminate embarrassment all around. Rest assured that there is no intent to be discourteous - the aim is simply to prevent any possibility of injury.

Thank you.

GLENN GOULD

Gould sometimes attempted to make light of his oddball reputation. "I don't think I am at all eccentric," he wrote. "It's true I wear one or two pairs of gloves most of the time and take a few sensible precautions about my health. And I sometimes play with my shoes off or get so carried away in a performance my shirttail comes out or, as some friends have complained, I look as though I were playing the piano with my nose." He was also willing to apologize for his singing: "I don't know how anyone puts up with it, but I play less well without it."

Still, he had been deeply serious about music for all of his life and he detested the way his concerts were now being treated as freak shows. "I had not regarded any of the things attendant upon my playing—my eccentricities, if you like—as being of any particular note at all," he told one interviewer. "Then suddenly a number of well-meaning people in the arts said, 'My dear young man, you must pull yourself together and stop this nonsense.' I had never given any thought to the importance, at least to some people, of visual image. When I was suddenly made aware of it in about 1956, I became extremely self-conscious about everything I did. The whole secret of what I had been doing was to concentrate exclusively on realizing a conception of the music, regardless of how it is physically achieved. This new self-consciousness was very difficult." Gould had begun to believe that the whole business of being a concert artist was getting in the way of making music.

In retrospect, some of his "eccentricities" now seem like common sense—none more so than his insistence upon soaking his hands in hot water before playing. Almost every early article about Gould refers to this "quirk" as an example of the "thin line between genius and madness" or something equally trite. But several important pianists who came of age during the 1950s—most notably Leon Fleisher and Gary Graffman—lost the use of one or both of their hands through what now sounds suspiciously like overwork. Similarly, in the late twentieth century, many computer users began to suffer from what has come to be known as repetitive strain injury, or RSI. It has since been discovered that one of the best ways to fend off RSI is to soak the hands alternately in hot and cold running water.

"Glenn Gould was utterly *brilliant* in that regard," Fleisher reflected in 1996. "He figured it all out. That's exactly what we should have all been doing—anything to bring that circulation back, anything to loosen the tension. But who knew?"

Card handed out by Gould to fans and reporters.

Throughout the late 1950s and early 1960s, Gould continued to play around the world, wearing his coats, soaking his hands, humming along and making music of unearthly beauty. There were European tours in 1958 and 1959, including a recital in Salzburg (since issued on disc) and performances of the first four Beethoven piano concertos with the London Symphony Orchestra and Josef Krips. The pace was exhausting. Within a period of four weeks (December 14, 1958, to January 9, 1959) he played a recital of works by Schoenberg, Mozart and Bach in Tel Aviv, Mozart's Concerto in C Minor (K. 491) in Detroit with Paul Paray, Beethoven's Concerto No. 4 in Minneapolis with Antal Dorati, Beethoven's *Emperor* Concerto in Houston with André Kostelanetz, and the Schoenberg-Mozart-Bach recital yet again, this time in Pasadena. He was also making some of his finest recordings: many of the Bach keyboard works; a first collaboration with Leonard Bernstein that coupled Bach's Concerto in D Minor with the Beethoven Concerto No. 2; a noble and arrestingly tragic rendition of Mozart's C minor concerto with Walter Susskind; and a brooding set of the Brahms intermezzi in 1960, proof positive that Gould could play Romantic music idiomatically and with vast reserves of feeling.

GLENN GOULD. Born in Toronto in 1932, Glenn Gould graduated from the Royal Conservatory of Music in Toronto at the age of twelve with the highest standing in Canada, the youngest musician ever to do so. He made his formal debut as soloist with the Toronto Symphony Orchestra in 1947. From that time on he has made many tours of Canada, appearing as soloist with all the major orchestras and giving recitals in all the major cities.

In 1955 Gould made his debut in the United States and in May, 1957, in Europe. His success as the first North American pianist to play in the U.S.S.R. was phenomenal. From Russia he went to Berlin, where he played with the Berlin Philharmonic Orchestra; H. H. Stuckenschmidt, Germany's most respected critic, called him 'the greatest pianist since Busoni'.

This series of concerts with the London Symphony Orchestra and Josef Krips will mark his first appearance in England.

The Orchestral Concerts Society Ltd.
in conjunction with
The London Symphony Orchestra Ltd.
announce

NINTH SERIES OF

BEETHOVEN
CONCERTS

LONDON SYMPHONY
ORCHESTRA
(Leader: HUGH MAGUIRE)

Conductor:
JOSEF KRIPS

Solo Pianist:
GLENN GOULD

Wednesday, May 20, 1959, at 8

Symphony No. 1
Piano Concerto No. 4
INTERVAL
Symphony No. 3, Eroica

Concert Management: HAROLD HOLT LTD.

In accordance with the requirements of the London County Council — (i) the public may leave at the end of the performance or exhibition by all exit doors and each door must at that time be open; (ii) all gangways, corridors, staircases and external passageways intended for exit must be kept entirely free from obstruction, whether permanent or temporary; (iii) persons shall not be permitted to stand or sit in any of the gangways intersecting the seating, or to sit in any of the other gangways.

However, a 1962 performance of Brahms's Piano Concerto No. 1 with Bernstein and the New York Philharmonic led to some of the most savage and unjustified reviews of Gould's career. A disagreement between conductor and soloist had arisen as the two men were preparing the concerto. Gould wanted to play it more slowly and meditatively than was customary, while Bernstein urged a traditional approach. Gould ultimately won out, but Bernstein felt it incumbent upon himself to step out before the performance and disassociate himself gently from what was to come.

Contrary to popular belief, Gould was all in favour of Bernstein's disclaimer. "Soloists and conductors disagree all the time," he said in 1982. "Why should this be hidden from the public, especially if both parties still give their all?" And, certainly, Bernstein churned up a fine fury from the Philharmonic, which played particularly well for him that afternoon; if he really didn't believe in the interpretation, one never would have known it from the performance, which was not issued on disc until 1985. (Indeed, Bernstein's later recording with Krystian Zimerman is actually *longer* than the interpretation he disputed in 1962.)

Still, the critics were almost unbelievably harsh. "A kind of agony set in, similar to

the feeling of impatience one experiences while riding in a delayed commuter train and counting off the interminable stops that separate one from one's goal," Winthrop Sargeant wrote in *The New Yorker*. According to Paul Henry Lang in the New York *Herald Tribune*, Gould was "suffering from music hallucinations that make him unfit for public appearances." Harold C. Schonberg, the chief critic of the *New York Times*, wrote his review in a sort of Yiddish dialect and addressed it to an imaginary friend: "Between you, me, and the corner lamppost, Ossip, maybe the reason he plays it so slow is maybe his technique is not so good."

Who needed such abuse? Certainly not the proud, sensitive Glenn Gould, who had already been planning his escape for some time. By 1963, he had reduced his schedule to eight appearances. There would be only two more after that—recitals in Chicago and Los Angeles in March and April of 1964—and then Gould abandoned the stage for good. He made no public announcement. In fact, there is some evidence that he had nothing so permanent in mind, as he later misremembered both the date and the place of his last concert. Still, he accepted no more engagements. "I simply cannot conceive of going back to that awful, transient life which, as you know, I never did enjoy," he wrote to a Russian friend, Kitty Gvozdeva, in February 1965. "But I have, however, been able to do much more recording than in earlier years."

Had anybody been willing to listen, Gould was more than prepared to explain his decision. He was tired of what he called the "non-take-two-ness" of the concert experience—the inability of a performer to correct finger slips and other minor mistakes. He pointed out that most creative artists were able to tinker and perfect, but that a live performer had to recreate his work from scratch in every concert. The result, in Gould's view, was a "tremendous conservatism" that made it difficult, if not impossible, for an artist to learn and grow.

Instead, Gould put his faith in what he called "The Prospects of Recording," to borrow the title of his most thorough explanation of the subject. "Technology has the capability to create a climate of anonymity and to allow the artist the time and freedom to prepare his conception of a work to the best of his ability," he said. "It has the capability of replacing those awful and degrading and humanly damaging uncertainties which the concert brings with it."

Flyer for Gould's Beethoven concerts, performed with the London Symphony Orchestra, 1959.

CBC promotional poster for *The Idea of North*, with Gould driving the train.

Gould took his case rather far, stating that the concert would die out by the year 2000 and that recordings—and recordings *only*—were the wave of the future. On one level, he was right, of course. Many of us know operas, symphonies and sonatas that we will never encounter in live performance. It was once necessary to travel to a small Bavarian village to experience Wagner's *Parsifal*; today, we can have a dozen recorded versions delivered to our doorstep by making a toll-free call. And, when Strauss's *Elektra* was telecast from the Metropolitan Opera House in 1981, it was estimated that more men, women and children saw and heard the work that single night than had ever attended a live performance since its premiere in 1909.

But the fact remains that many listeners—and musicians, too, for that matter—love concerts, and certainly the institution shows no signs of dying out. It is interesting to compare Gould's feelings about performing with those of Arthur Rubinstein. In 1970, the two men met, and the resulting dialogue was published in *Look* magazine.

Rubinstein spoke excitedly of "the feeling at the beginning when the audiences arrive—they come from a dinner, they think about their business, the women observe the dress of other women, young girls look for good-looking young men, or vice versa—I mean, there is a tremendous disturbance all over, and I feel it, of course. But if you are in a good mood, you have the attention of all of them. You can play one note and hold it out for a minute—they will listen like they are in your hand."

"Was there never a moment when you felt that very special emanation from an audience?" Rubinstein asked Gould. "You never felt you had the souls of those people?"

"I didn't really want their souls, you know," Gould replied. "Well, that's a silly thing to say. Of course, I wanted to have some influence, I suppose, to shape their lives in some way, to do 'good,' if I can put an old-fashioned word on it, but I didn't want any power over them, you know, and I certainly wasn't stimulated by their presence as such. Matter of fact, I always played less well because of it."

"There we are, absolute opposites, you know. We are absolute opposites!" Rubinstein said. And yet the affection and admiration between the two men was genuine; Gould told Rubinstein that his recording of the Brahms Piano Quintet was "the greatest chamber-music performance with piano that I've heard in my life."

Another musician Gould venerated was Leopold Stokowski, whom he considered the first classical artist to have explored recording as an art form in itself. The two collaborated on an album of Beethoven's Piano Concerto No. 5 (the *Emperor*), and Gould later created a radio documentary and then a funny and insightful essay about the conductor. (The cellist Pablo Casals and the composer Ernst Krenek were two other subjects of Gould's radio portraits.)

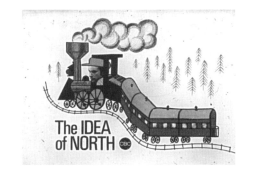

The CBC has now issued several of Gould's radio dramas on disc. Of these, the most representative are the three that comprise the "Solitude Trilogy"—*The Idea of North* (1967), *The Latecomers* (1969) and *The Quiet in the Land* (1977)—made up of interviews, sound effects (*The Latecomers* is accompanied by the sound of the tide lapping on the beaches of Newfoundland) and, very occasionally, some concert music (the finale of Sibelius's Symphony No. 5 is also the finale of *The Idea of North*).

Gould believed that there was a musical dimension in the phonetic sound of the spoken word that had been ignored in traditional radio. "When *The Idea of North* first came out, in 1967, the fashionable word was 'aleatory' and some critics were quick to apply this term to my work," he told me in 1980. "Nothing could have been further from the truth, and to counter this impression, I began to speak of 'contrapuntal radio,' implying a highly organized discipline—not necessarily leading to a fugue in every incident, but in which every voice leads its own rather splendid life and adheres to certain parameters of harmonic discipline. I kept a very close ear as to how the voices came together and in what manner they splashed off each other, both in the actual sound and in the meaning of what was being said."

The North had fascinated Gould since childhood. He associated it with order, cleanliness and quietude and he observed that most people who immersed themselves in the North "seemed to end up, in whatever disorganized fashion, being philosophers.

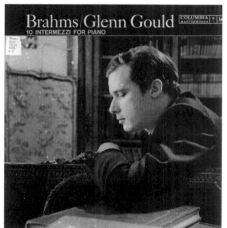

Album cover of Gould's first interpretation of Brahms piano music, released by Columbia in 1961.

"None of them were born in the North," he continued. "They all chose to live there, for one reason or another. Whatever their motive in moving north may have been—and it varied from person to person—each individual seemed to go through a particular process which greatly altered his life. At first, most of these people resisted the change: they reached out, contacted friends, made sure their subscription to *The New Yorker* was intact and so on. But after a while they usually reached a point when they said to themselves: 'No, that's *not* what I came up here to do.'

"In general, I found that the characters who had stuck it out long enough and removed themselves from the sense of curiosity about what their colleagues were thinking, or how the world reacted to what they had done, developed in an extraordinary way and underwent an extreme metamorphosis. But I think that this can be true of anybody who chooses to live in an isolated way—even in the heart of Manhattan. I don't think the actual latitudinal factor is important at all."

It was this willingness to remake the world *tabula rasa* that set Gould apart as musician and thinker. Paul Myers, who produced many of Gould's early recordings, summed up the pianist's approach to music: "He is never concerned with traditional views of interpretation, nor with the already-recorded versions of a work which are regarded as the yardsticks of performance. Instead, he prefers to perform a piece almost as though it were newly composed, awaiting its first interpretation. When he is in the studio, he likes to play as many as ten or fifteen interpretations of the same piece—each of them quite different, many of them valid—as though examining the music from every angle before deciding upon a final performance. This, in itself, is a rarity, for there are few pianists who have the technique equal to the task. His provocative musical ideas, backed by complete integrity of purpose and thorough academic understanding of the technical workings of a piece, make him either a musical devil's advocate or *enfant terrible*, depending on your point of view. One thing is certain: a Glenn Gould performance is unmistakably original and the result of extensive study and consideration, both at and away from the piano."

"Glenn Gould is an exceedingly superior person, friendly and considerate. He is not really an eccentric, nor is he egocentric. Glenn Gould is a person who has found out how he wants to live his life and is doing precisely that."

GEOFFREY PAYZANT

As Payzant observed, Gould spent the last eighteen years of his life living pretty much the way he wanted—arising in the late afternoon, washing down pots of weak tea, telephoning his friends all over the world, working on various projects throughout the night, finally taking his one meal of the day at six or seven in the morning, just before his bedtime. Although he kept a penthouse apartment at 110 St. Clair Avenue West, just north of downtown Toronto, he spent most of his nights in hotels, usually the Inn on the Park, at the corner of Eglinton and Leslie, which he favoured for its twenty-four-hour room service, and where he also maintained a studio.

His hotel studio was cell-sized—windows blocked, curtains drawn, and cluttered with tapes, tape machines, video recorders, some reading material, pads of paper, an inexpensive stereo and a television. (Gould just missed the advent of the home computer—how he would have loved the Internet!) He played the stock market with aplomb, watched *The Mary Tyler Moore Show* whenever possible and liked to drive at reckless speed through the streets of Toronto in the earliest hours of the morning. When he left his home province, it was usually to visit New York for professional reasons or, during the coldest months of the year, to take an off-season vacation on one of the barrier islands that line the shores of Georgia.

To be sure, it was an unusual and idiosyncratic way for a "star" to live. But Gould managed to be extraordinarily productive during these years. He wrote voluminously about music, musicians and recordings. He hosted dozens of radio programs for the CBC and collaborated with the filmmaker John McGreevy on a documentary about Toronto. The BBC produced four brilliant "Conversations with Glenn Gould" programs in which he discussed Bach, Beethoven, Strauss and Schoenberg with Humphrey Burton. He appeared on his friend Yehudi Menuhin's televised survey, *The Music of Man*, an early exercise in multiculturalism. And he continued to make recordings—more Bach, sonatas by Beethoven and Haydn, oddities by Bizet, Grieg and Sibelius, transcriptions from Wagner operas, a wrenchingly lovely disc of music by William Byrd and Orlando Gibbons, and many others.

After 1970, Gould chose to do most of his recording in Toronto, where he was able to book Eaton Auditorium, the site of so many of his early musical memories. By all accounts, the hall had excellent acoustics, but it is likely that sentiment had a great deal to do with Gould's devotion, and he took its closure in 1980 as a personal affront. (Although it was scheduled for demolition, against all odds the building still stands, and has been renovated to reopen in 2003.)

Andrew Kazdin, who worked as Gould's producer for fifteen years, described in detail their last session in the shuttered Eaton Auditorium: "It looked as if a bomb had hit the place. Walls were missing, doors were boarded up. There were no lights. There was no heat." The last sessions took place in October 1979, when the weather had already begun to turn cold, and Gould arranged to import four large space heaters into his makeshift studio. "These devices, somewhat resembling jet engines, were placed in the aisles of the auditorium and were powered by tanks of gas. They emitted a furnace-like roar and could be turned on only when we were not actually taping. So the room would be brought up to a temperature that would sustain human life, and then the heaters would be turned off so that music could be recorded. From time to time throughout the evening, the hall was given a kind of 'booster shot' of heated air." Gould selected a photograph of himself, standing morosely amidst the wreckage of Eaton Auditorium, to adorn the cover of one of his last LPs.

The first page of Gould's eulogy for his mother, written on the stationery of the Four Seasons Hotel, which was across from the original CBC building on Jarvis Street, Toronto.

This may have reflected his state of mind at the time, for the late 1970s was a difficult period for Gould. The death of his mother in 1975 sent him into a dark depression. Shortly thereafter, he began to have difficulty playing the piano. Although Gould himself thought it "quite possible, even likely" that many of these problems had a psychological base, his concerns were none the less real, and he made no recordings for more than a year To compound his anxiety, he was diagnosed with hypertension and began keeping an astonishingly detailed log of his symptoms, measuring his blood pressure as often as every fifteen minutes. He added blood-pressure medications to the sleeping pills, Valium and other tranquilizers he had taken regularly for decades. His hypochondria, always acute, redoubled, but there were some disturbing signs that Gould was no longer a well man.

In 1980, Gould celebrated his twenty-fifth anniversary with Columbia Records (which was then known as CBS Masterworks and would soon become Sony Classical) To mark this occasion, the company brought out a two-record set entitled "The Glenn Gould Silver Jubilee Album." One disc was devoted to previously unreleased performances of works by Scriabin, Richard Strauss, C.P.E. Bach and Domenico Scarlatti. But it was the second disc that received most of the attention. "A Glenn Gould Fantasy" was the first commercial release of any of Gould's "docudramas" and featured him in roles such as Sir Nigel Twitt-Thornwaite, a pompous English musicologist; Karlheinz Klopweisser, a theory-drunk German avant-garde composer; and Theodore Slutz, a stoned-out culture writer for *The New York Village Grass Is Greener*. The conclusion of this program—a "hysteric return," in which Gould plays Ravel's "La Valse" to some barking seals somewhere in the frozen north—is a minor classic of surrealism.

The Four Seasons Hotel
Toronto

① Florence Greig Gould came from a Christian home. From the time she was a teenager, she devoted her life to classical music — and, in particular, to music for the sacred service — being active in church and young peoples' groups. After she came to Toronto for further study in vocal and instrumental music, she devoted her talents primarily to church music, turning down

415 Jarvis Street, Toronto, Ontario M4Y 2G8, Canada

I came to know Gould that fall, when he granted me an interview for the *Soho News*, an arts magazine for which I was music critic. I had answered an open call when Susan Koscis, the publicist for CBS Masterworks, made it known that Gould would speak on the phone to a few journalists whose questions, submitted in advance, caught his interest. And so I stayed away from the standard litany of queries about Gould's perceived quirks—subjects that didn't especially attract me to begin with—and concentrated instead on his radio work, his involvement with the North, his love for Sibelius and Strauss.

The *Soho News* had a tiny circulation and I didn't think I had a chance of getting the interview, but Gould assented, and we spoke for two hours one Saturday night. (The piece was later included in *The Glenn Gould Reader*, a collection I edited after his death.) Unfortunately, the *Soho News* was then under the direction of a particularly acerbic arts editor; she agreed to put Gould on the cover but invented a headline that called him a "pianist and crank."

A *crank!* I was horrified and left a profuse apology with Gould's answering service, convinced that my contacts with him were at an end. But he called back a few minutes later, told me that he understood the pitfalls of journalism and that he loved the piece. After that, we were friends—it was as simple as that—and he called regularly, usually late at night, and we would talk for hours.

Conversation was one of Gould's greatest joys. He was a superb mimic and an inspired raconteur, capable of spinning out a yarn for more than an hour, in minute detail. He was witty, kindly, energetic and intensely interested, and extended an instant camaraderie to anybody whose company, telephonic or otherwise, he enjoyed. One evening, he called to sing the Brahms G Minor Rhapsody in its entirety, to make what remained an obscure point about tempo relations in the score. Another night, he read through several pages of Timothy Findley's novel *The Wars*; he had provided the music for a grave and beautiful motion picture based on the book. And once, impressed by an article I had written for *High Fidelity* about minimalist music—which fascinated him, although he detested it—he sang an impromptu "minimalist" song to my answering machine.

A song written for CBC broadcaster Margaret Pascu, by "Karlheinz Klopweisser," one of Gould's many personas.

I had always assumed I would never meet Gould in the flesh and had grown comfortable with the idea. He felt that personal encounters were by and large unnecessary and claimed that he could better understand the essence of a person's thought and personality over the phone. (His monthly phone bill ran to four figures.) One evening, however, I asked if I might visit him in Toronto; a magazine called *Vanity Fair* was starting up and some editors had expressed interest in a story. To my surprise, he liked

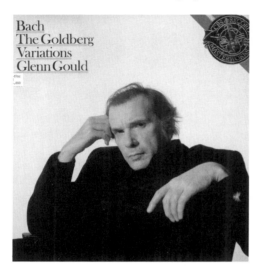

the idea and even suggested a project we might do together—a radio interview about his recent re-recording of the *Goldberg Variations*.

He had come to despise the earlier version, speaking of it in stentorian tones as "the most overrated keyboard disc of all time." Special contempt was reserved for his performance of the amazing Variation 25, which he felt he had played "like a Chopin nocturne." "It wears its heart on its sleeve," Gould said. "It seems to say—Please Take Note. This is Tragedy. You know, it just doesn't have the dignity to bear its suffering with a hint of quiet resignation." The new recording was much more sober and introspective, with generally slower tempos; in retrospect, it has the profound and terrible sense of a summing up. (A film of the recording session was issued by the French company Clasart and remains one of the most persuasive matings of music and imagery I've ever seen.)

I showed up at the Inn on the Park on August 20, 1982, and finally met Glenn Gould. I was immediately shocked by his appearance. Rumpled, heavy-set and balding, with skin like bleached parchment, he looked much older than his forty-nine years, with the air of a tired visitor preparing to cast off his wasted body. And yet, after he gently shook my hand and we sat down to talk and listen to his latest productions, he exuded immense curiosity and a teasing humour, as if he were the world's oldest mischievous little boy.

We worked all night on our interview, and when it was over—about 6 A.M.—I excused myself for a moment. When I returned, Glenn was seated at a Yamaha baby grand and had begun to play through his own piano arrangements of Richard Strauss operas. I was absolutely exhausted—I remember it was the first time I'd ever understood the familiar cliché about pins and needles—but remained cognizant enough to wake myself up and pay heed. *Glenn Gould was playing the piano for me!* And the Yamaha became a six-foot-square orchestra; dense contrapuntal lines, translucently clear and perfectly contoured, echoed through the empty room. After lengthy fragments of *Elektra* and *Capriccio*, Glenn started to play part of the *Goldberg Variations*, but interrupted himself after a few bars, saying that he could not possibly play Baroque music without his beloved, battered folding chair. And so he turned to the second movement of Beethoven's Piano Concerto No. 2, singing along, conducting with one hand whenever he could free it up, lost in the joy of making music.

This memory is one reason why the popular impression of Gould as haunted neurotic, moping nobly through life, doomed and misunderstood, with the glint of genius forever in his eyes, has always struck me as only partially accurate. I remember watching *32 Short Films about Glenn Gould* for the first time and, while admiring much of it and applauding the filmmaker's intentions at all times, I found everything so solemn and reverential that it was impossible to escape an occasional flashing memory of Gould's gleeful, childlike, self-deprecating laughter—the laughter with which I suspect he would have greeted all latter-day attempts to portray him as "Saint Glenn."

My own memories of Gould are happy ones—he was always tremendous fun, playful and allusive, and very little of that comes across in *Thirty-two Short Films*. If there were some way to cross it with something silly and inspired such as a Monty Python episode, a more rounded picture of Gould might emerge. Still, it must have been very difficult to be Glenn Gould, for his fundamental aloneness was overwhelming. He lived by himself, controlled all of his friendships and, so far as can be determined, had only few and fleeting romantic attachments, with women who were ultimately unavailable to him. Indeed, he seemed to have no love life at all in later years. "Monastic seclusion works for me," he said, with no perceptible dismay.

Cover for Gould's second recording of Bach's *Goldberg Variations*, released in September 1982, just before he died.

Press release from Toronto General Hospital announcing Gould's death, October 4, 1982.

It has been suggested that Gould showed some symptoms of Asperger syndrome, a form of high-functioning autism that may also have affected geniuses as divergent as George Fox, Ludwig van Beethoven, Ludwig Wittgenstein, Jascha Heifetz and Howard Hughes, to name only a few. Gould shared many qualities with these men—profound self-direction, a photographic memory, a marked preference for unbroken routines, extreme discomfort in most social situations, a penchant for isolation, inflexible obstinacy on certain matters and a generalized, irremediable anxiety that often bordered on panic.

Yet the condition is not without redeeming features, for some individuals with Asperger syndrome are gifted with such single-minded concentration that they are capable of extraordinary accomplishments. One thinks of Samuel Johnson, another probable "Aspie," assembling his unprecedented *Dictionary of the English Language* all by himself in the upper room of a townhouse off Fleet Street. One thinks of Paul Morphy or Bobby Fischer, blindfolded, playing several games of chess at once and winning them all. And, finally, one thinks of the legacy of Glenn Gould.

He left us a great deal—more than fifty hours' worth of commercial recordings (in addition to the "live" performances that continue to crop up every now and again); the radio and television programs; the soundtracks to two films, *Slaughterhouse-Five* (1972) and *The Wars* (1982); and some of the freshest and most intrepid music criticism of the late twentieth century.

But there would have been much more. Gould was already beginning a new career as a conductor (his 1982 interpretation of Wagner's "Siegfried Idyll" with a pick-up orchestra was one of great tenderness, and he planned to follow it up with recordings of Strauss's "Metamorphosen" and Beethoven's Piano Concerto No. 2, with the gifted young Jon Klibonoff as the soloist). There might have been some new compositions to complement the expansive String Quartet, opus 1, a work that dates from Gould's early twenties and shows him to have been a convinced "neo-Romantic" long before the term became fashionable. According to producer John P.L. Roberts, who knew him as well as anybody, "Glenn had the next twenty years all planned out."

It was not to be. Gould's magnificent brain betrayed him at around 2 P.M. on September 27, 1982, as he lay sleeping in his room at the Inn on the Park. He awoke in a panic and realized immediately that he was gravely ill. His friend and aide Ray Roberts rushed him to Toronto General Hospital, where a severe stroke was diagnosed. He rallied briefly, then sank into an irreversible coma and was removed from life-support systems on the morning of October 4.

The news of Gould's death was carried on the front pages of newspapers around the world, and his memorial service at the Anglican Church of St. Paul's was filled to overflowing. He is buried in Mount Pleasant Cemetery, just beyond downtown Toronto, on endless Yonge Street as it makes its way north toward the "starkly magnificent beauty" he loved so dearly and mirrored in his work.

"The purpose of art is not the release of a momentary ejection of adrenaline but rather the gradual, lifelong construction of a state of wonder and serenity," Gould wrote in 1962. That art remains, immortalized in recordings, films, writings—and the photographs in this volume—and it will endure.

1829-1979
TORONTO GENERAL HOSPITAL

101 College Street, Toronto, Ontario, Canada M5G 1L7

NEWS RELEASE

PIANIST GLENN GOULD DIES

The family of Glenn Gould announce with profound regret that Glenn died on the morning of October 4, 1982 at 11:30 a.m. at Toronto General Hospital.

Mr. Gould, age 50, was admitted to the hospital on Monday, September 27th having suffered a severe stroke.

There will be a private family funeral service.

A memorial service is being arranged and details will be announced later.

- 30 -

FOR RELEASE: Upon receipt

DATE: October 4, 1982
CONTACT: David Allen
 Pauline Jackson
 Public Relations
 Toronto General Hospital
 101 College Street
 Toronto, Ontario M5G 1L7
 Telephone: (416) 595-3303

150 Years of Patient Care, Teaching and Research

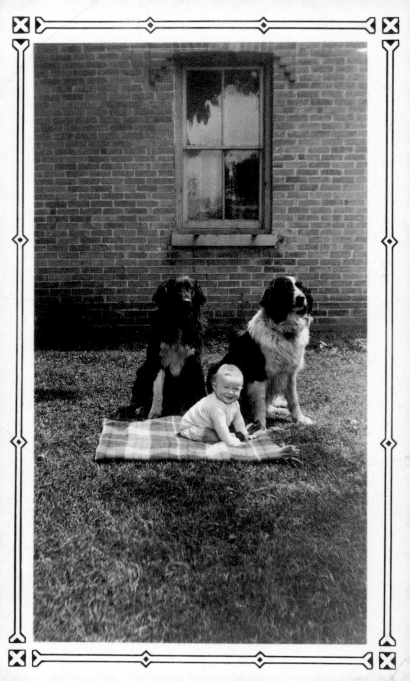

OVERTURE

Glenn, age eight months. Growing up, Glenn owned many dogs. The one on the right—Buddy—was his first.

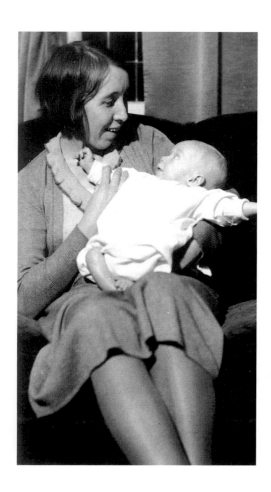 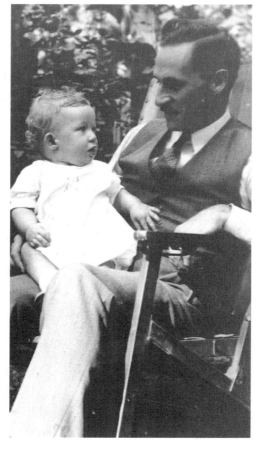

(FAR LEFT) At four months, with his mother, Florence Gould. "Flora would play all sorts of classical music while she was pregnant because she so wanted the child to be musical and because she was so musical herself." (Bert Gould)

(LEFT) Age eleven months, with his father, Bert Gould, in the backyard of their Southwood Drive home in the Beach neighbourhood of Toronto.

(OPPOSITE) In the garden of their family home. Toddler Glenn already has a different perspective on the world.

(OVERLEAF) Baby Glenn about seven months, with lawn ornaments.

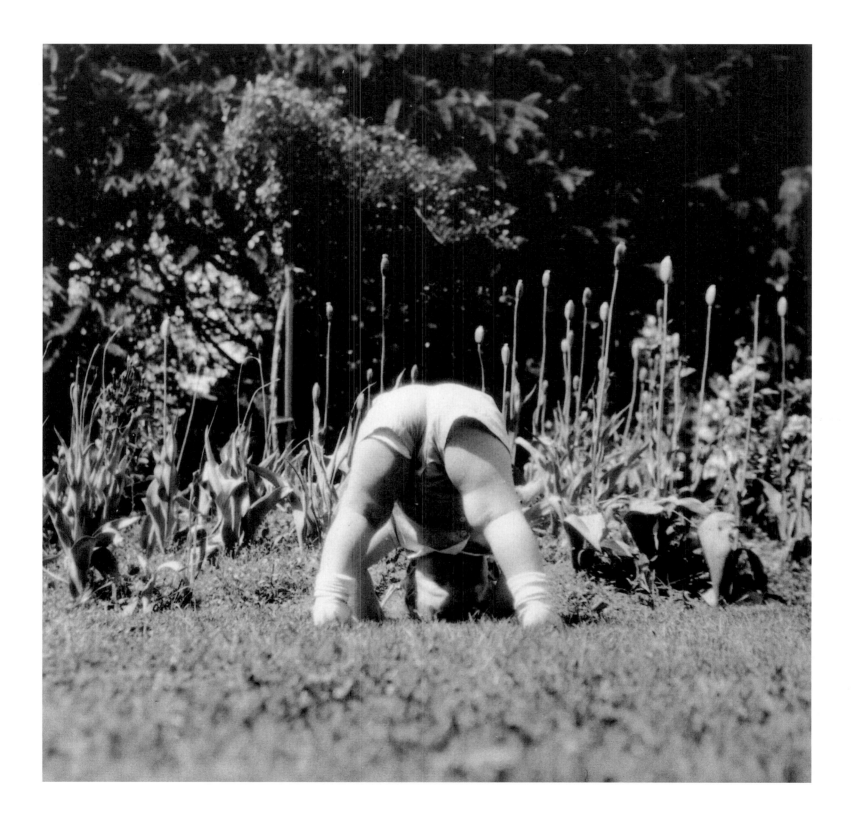

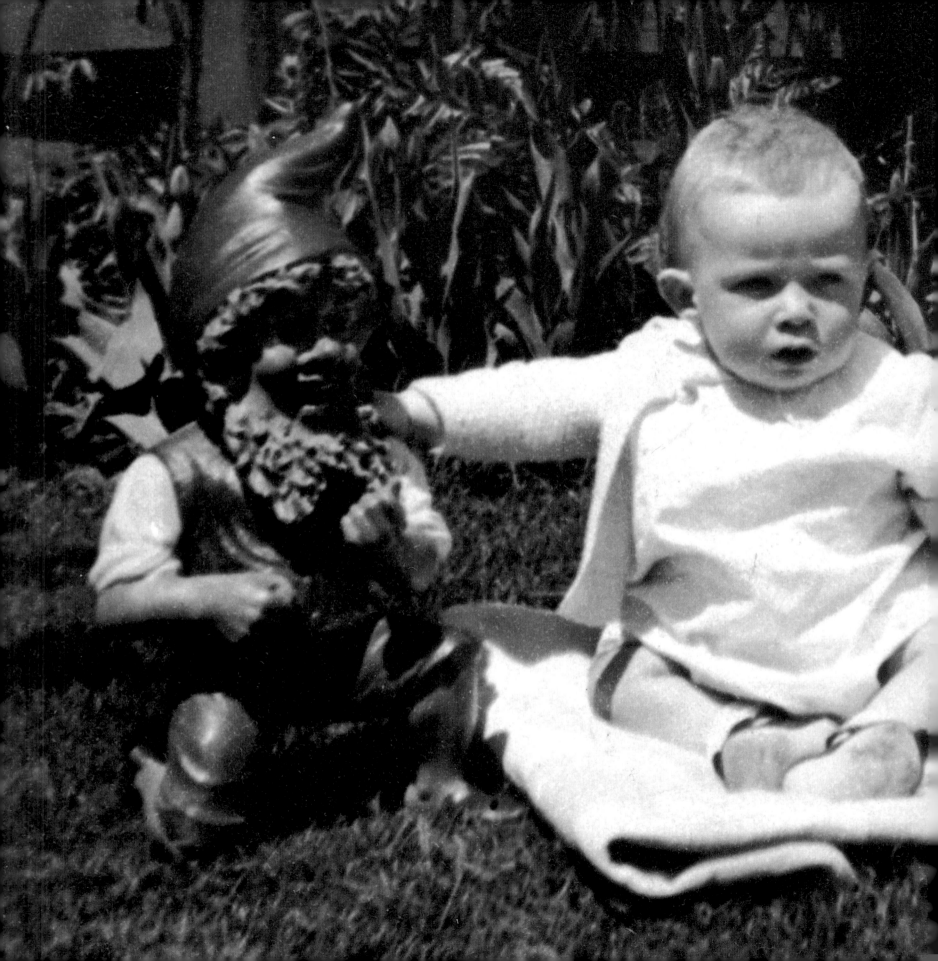

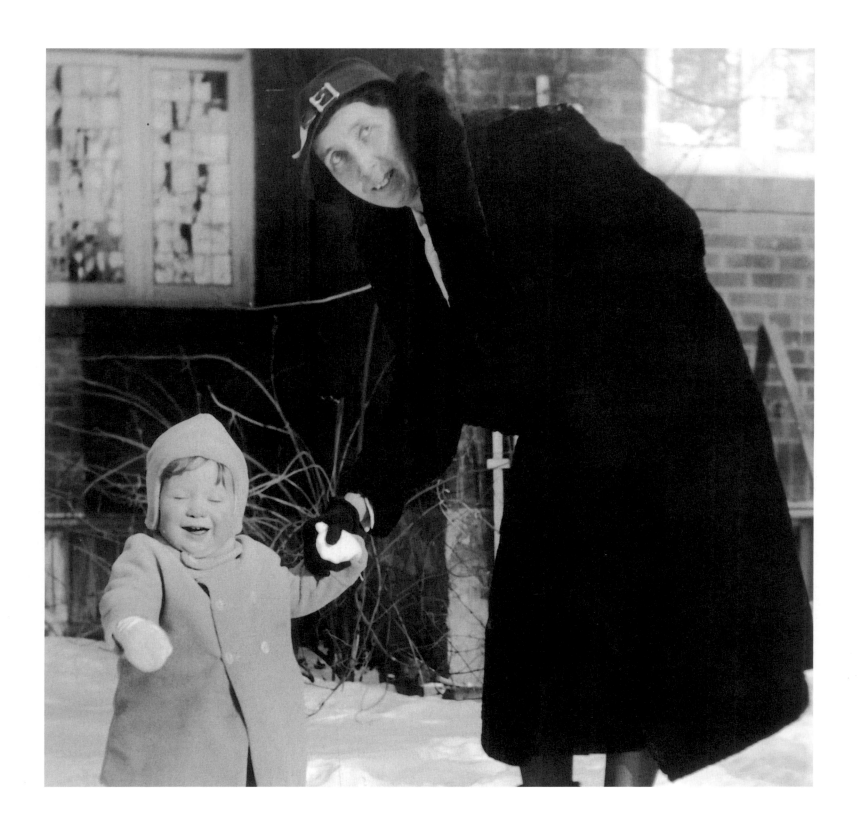

GLENN GOULD ❦ A Life in Pictures

"After long hours of practice [Glenn] would lay his head [on his mother's knee] and demand 'pats' as one would give a dog. These pats were a reward for a day well spent and a fulfillment of his great need for love and acceptance." JESSIE GREIG

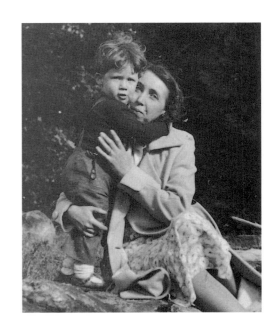

At about two years old, with his mother. Florence Gould (née Greig) claimed a distant connection to composer Edvard Grieg. She worked for many years as a voice teacher in Toronto, devoting her talents primarily to church music. Of his mother, Gould later wrote: "Florence Gould was a woman of tremendous faith and wherever she went, she strove to instill that faith in others."

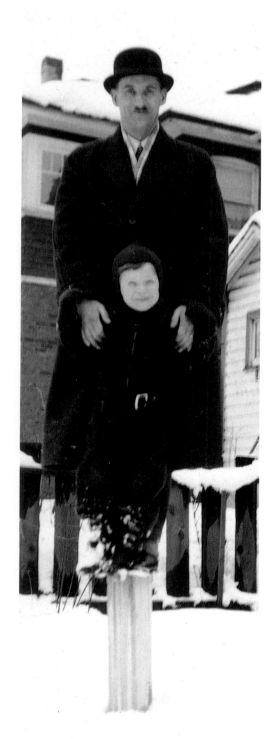

(LEFT) Glenn, balanced on a birdbath stand, with his father. (OPPOSITE) In the backyard on Southwood Drive. Russell Herbert Gould was a successful furrier and avid churchgoer, with some musical talent of his own: he sang in the church choir and had played the violin. At the age of five, Glenn told his father, "I'm going to be a concert pianist."

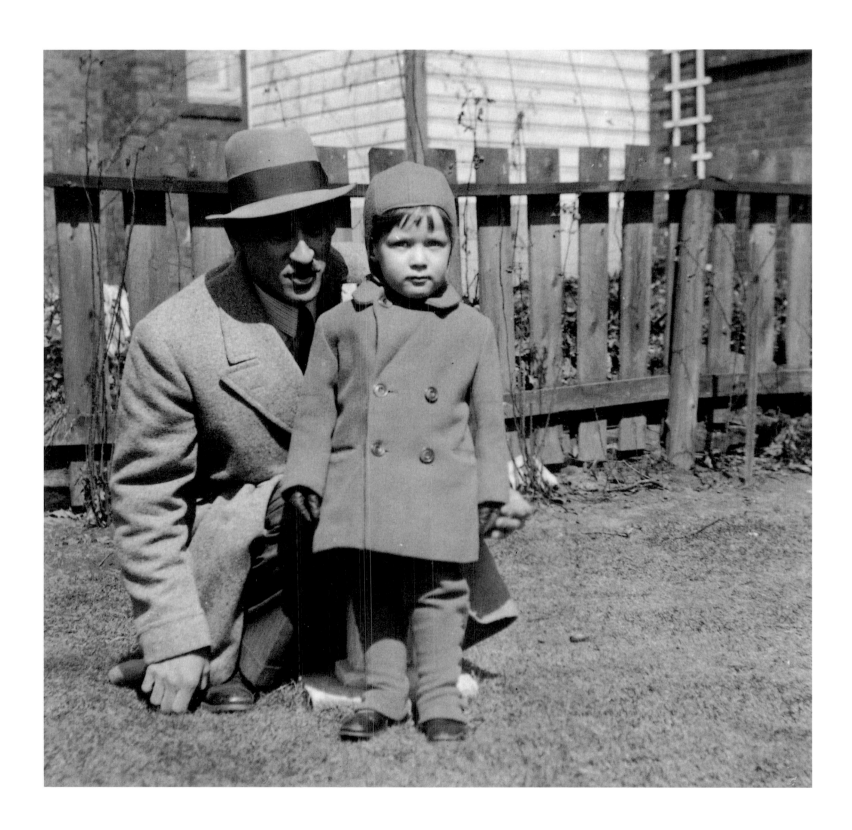

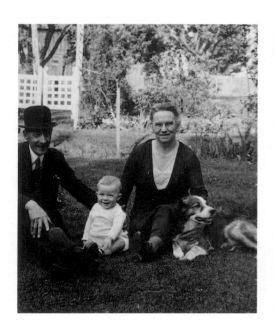

With his paternal grandparents, Thomas and Alma Gould, (FAR LEFT) at about eight months and (LEFT) as a young teenager. (OPPOSITE) With his maternal grandmother, Mary Catherine Greig. Florence Gould began Glenn's music lessons when he was three, continuing as his teacher until he was ten.

Playing in the water at the family cottage near Uptergrove, Ontario, on Lake Simcoe, about 100 kilometres north of Toronto.

Glenn shows an early sense of mischief.

GLENN GOULD ✑ A Life in Pictures

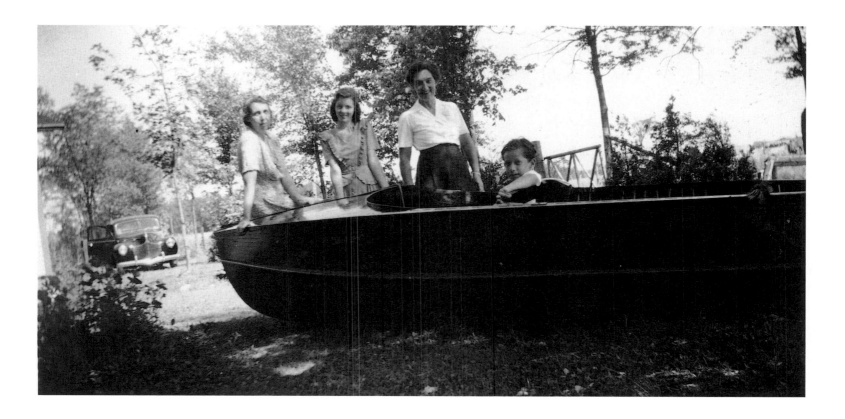

At Uptergrove, with friends and family. (OPPOSITE) Florence Gould is standing and grandmother Mary Catherine Greig is seated on the left. (ABOVE) Glenn's first boat, with Florence Gould seated on the bow. It was a 15-foot cedar skiff with an electric motor, which Glenn steered with a wheel in the bow. "Glenn was never happier than when he was in the water with his boat and his dog." (Bert Gould)

(OVERLEAF) At Williamson Road Public School, during the Second World War. Glenn is in the far row, third from the front. Glenn's school years were difficult. He was absent a great deal, partly because of ill health and partly because of the long hours he spent at the piano. The neighbourhood kids used to pick on him; there were stories that he was beaten up every day. According to Glenn, that was an exaggeration: "It was only every other day."

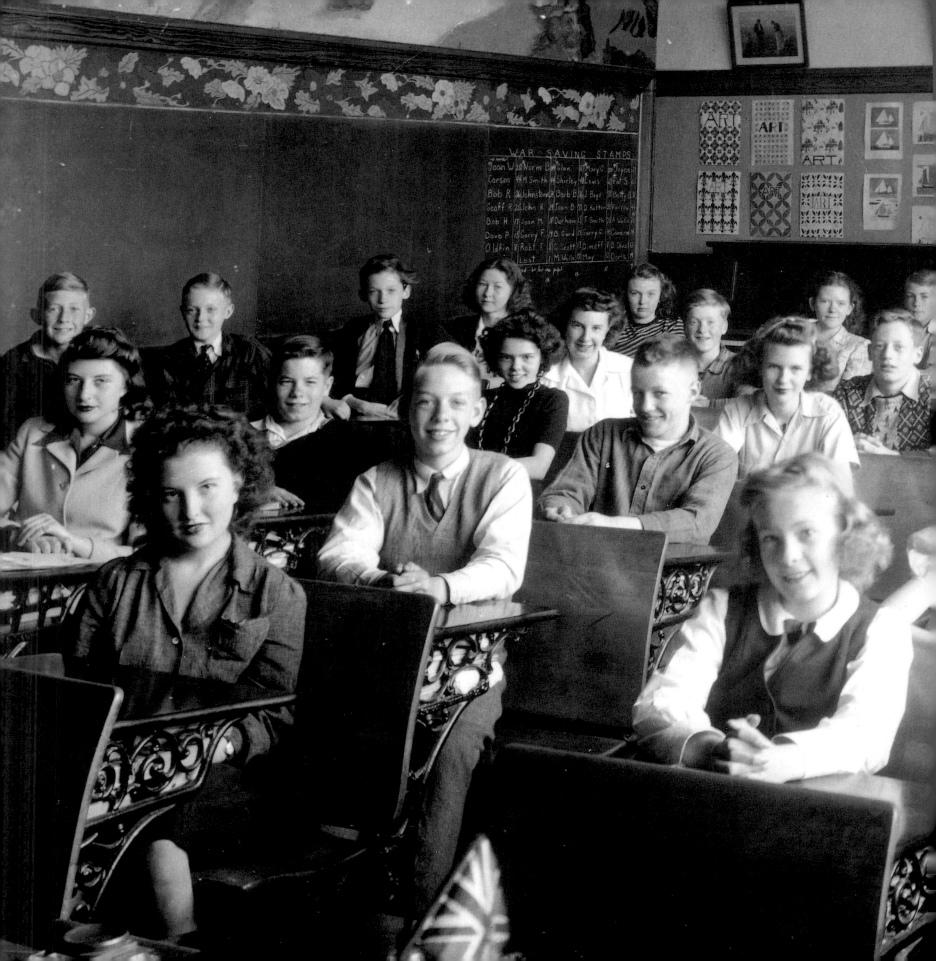

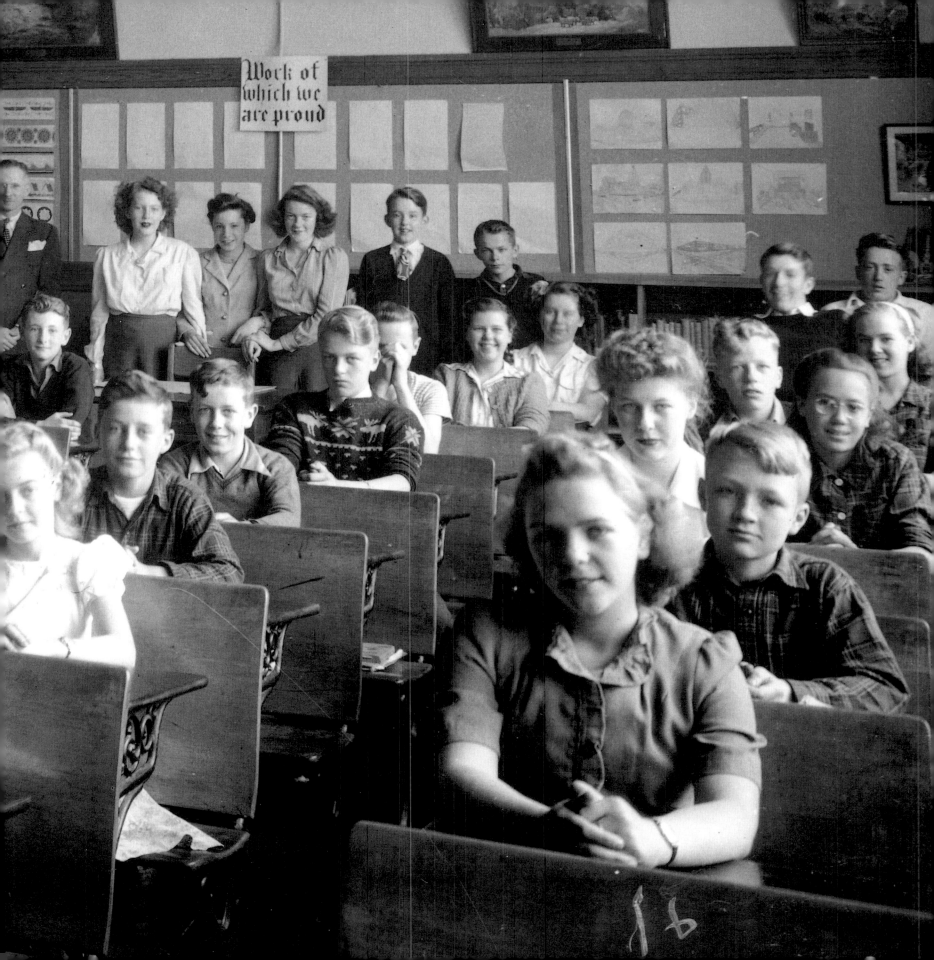

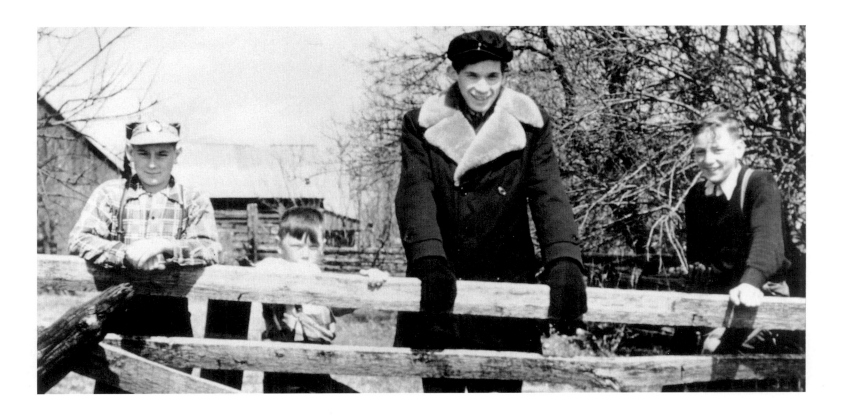

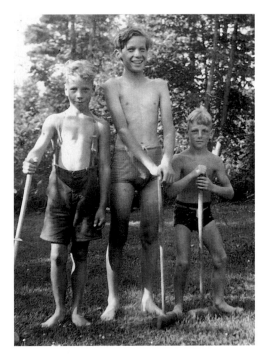

With childhood friends. (ABOVE) At a farm near the cottage. (LEFT) Glenn, flanked by two croquet-playing buddies.

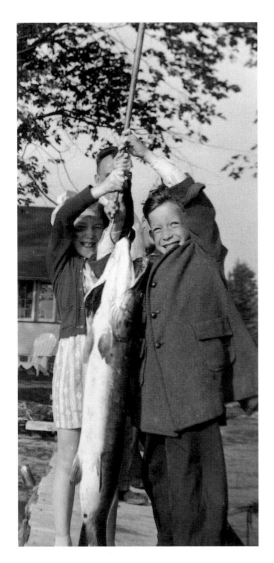

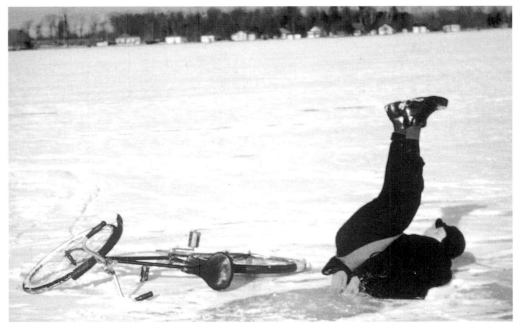

(LEFT) On the dock in front of the cottage. Glenn recalled going fishing with a neighbour's family and feeling very proud after he caught his first fish. When he realized that his prize catch was dying, he wanted to put it back in the water. "The others laughed at me. But the more they laughed, the more I shouted, until I finally broke up the fishing party with a screaming tantrum. I've been a violent anti-fisherman ever since." (RIGHT) Glenn clowns after a spill on frozen Lake Simcoe.

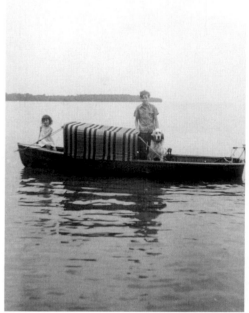

Summer idylls. (LEFT) With his beloved dog, Nick; (RIGHT) relaxing on his boat with Nick and a friend; (OPPOSITE) playing croquet with his mother. The cottage was a central part of Glenn's life from early childhood. Later, it became a place of "sanctuary and sanity . . . where [he] could be most privately, and most simply, himself." (Angela Addison)

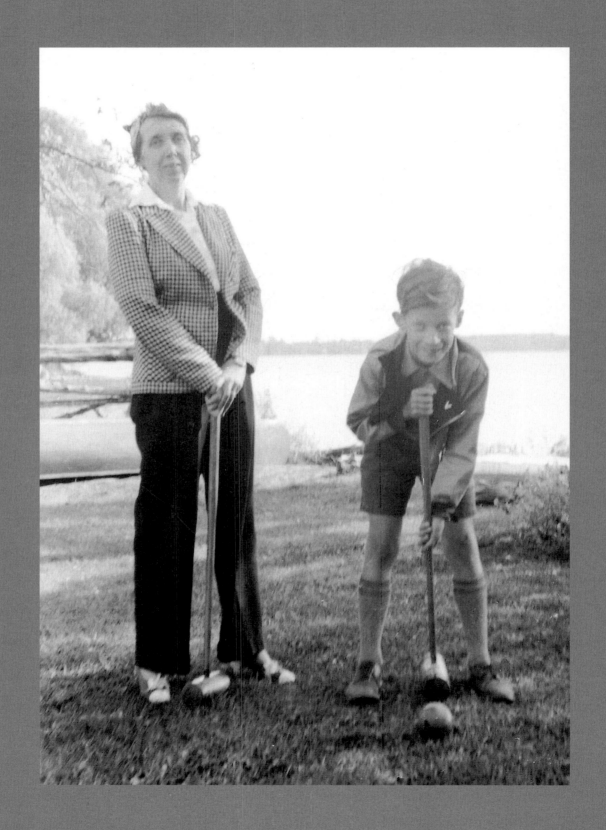

With Nick, his English setter, in a formal
portrait, 1942.

A year later, with Nick outside his home on Southwood Drive. Glenn loved animals of all kinds: "I've had rabbits, turtles, fish, birds, dogs, and a non-deodorized skunk." Nick would often sit next to Glenn while he practised piano. The dog was a favourite companion, upon whom Glenn bestowed the courtly title Sir Nickolson of Garelocheed.

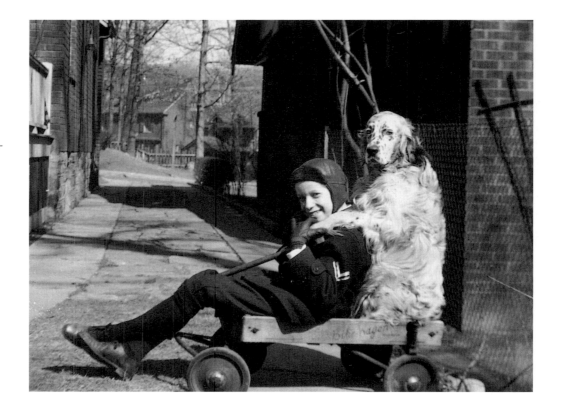

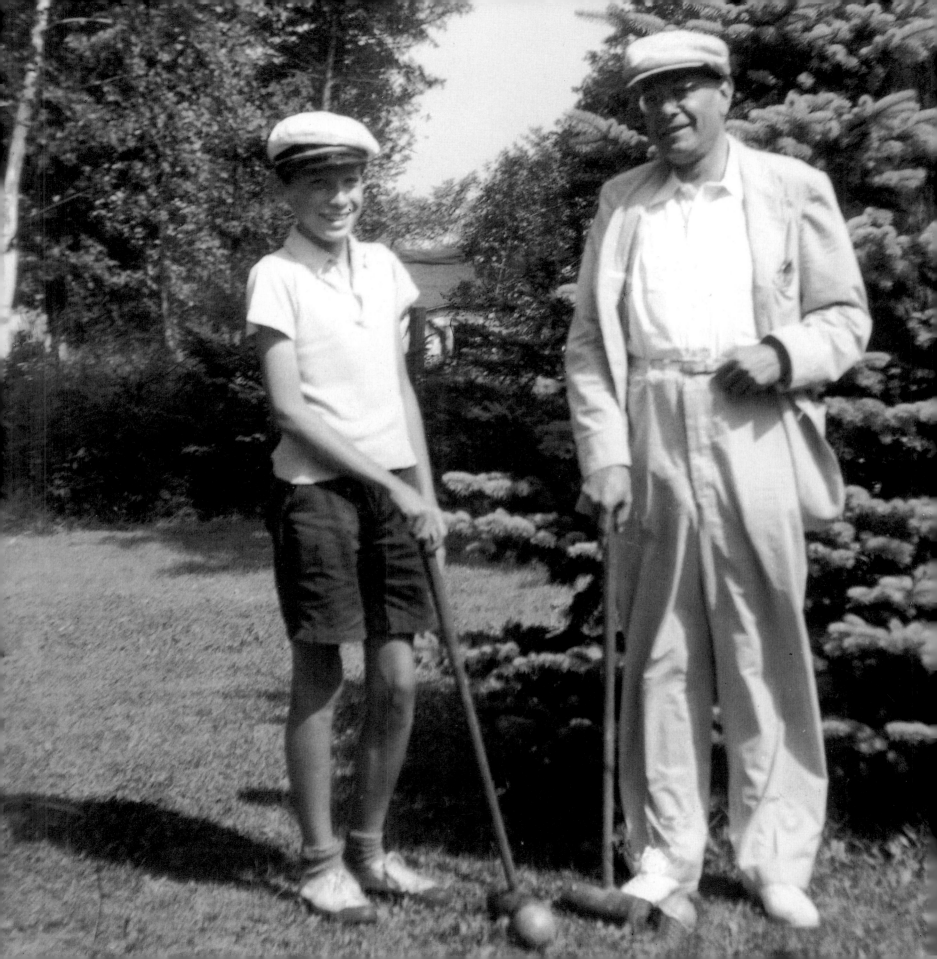

Playing croquet with his piano teacher, Alberto Guerrero, at about age eleven. Guerrero, who began teaching Glenn when he was ten, was born in Chile and was a celebrated concert pianist as well as conductor of Santiago's first symphony orchestra. He came to Canada in 1919 and was in his mid-fifties when he became Glenn's teacher. Gould would later say that his teenage studies with Guerrero were "essentially exercises in argument. They were attempts to crystallize my point of view versus his on some particular issue." The struggle was not merely verbal. Guerrero had devised a complex set of finger drills for Glenn, and would push down on Glenn's shoulders as the boy played—with Glenn pushing back. The teacher, of course, prevailed.

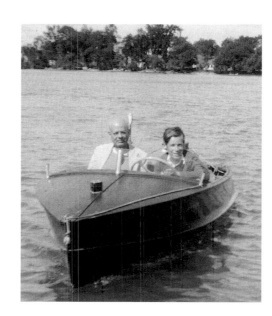

Driving his boat, with Guerrero as passenger.

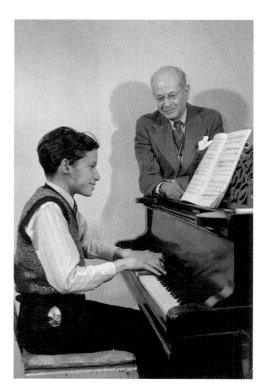

At age eleven, with his teacher.

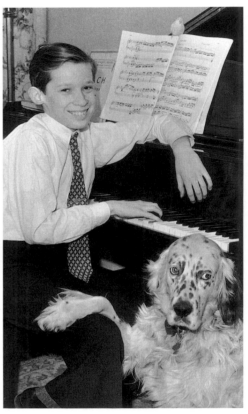

"His mother, his only teacher in the early years, was wonderfully wise in dealing with him and in providing the atmosphere best suited to his needs. Every opportunity was given to him to hear the best music that the city of Toronto could provide. Glenn was never exploited, never pushed to the forefront, and allowed to move into musical circles when he felt ready."

JESSIE GREIG

(ABOVE LEFT) The young prodigy practising a Christmas carol, age six or seven. (ABOVE RIGHT) Age twelve, with Mozart (the budgie) and Nick. (OPPOSITE) A formal portrait taken a year earlier.

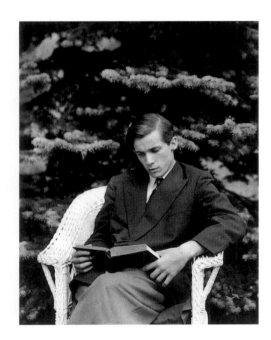

Glenn reading at the family cottage—as always, with an eye to his image.

(OPPOSITE) At age thirteen. Around this time, Glenn had an epiphany about the power of imagi-nation. He recalled that, because of the noise of a nearby vacuum cleaner, "in the softer passages [of a Mozart fugue I was playing] I could sense the tactile relation with the keyboard . . . and I could imagine what I was doing, but couldn't actually hear it." Glenn concluded that the artist must always re-evaluate what he has been taught against "that vast background of immense possibility."

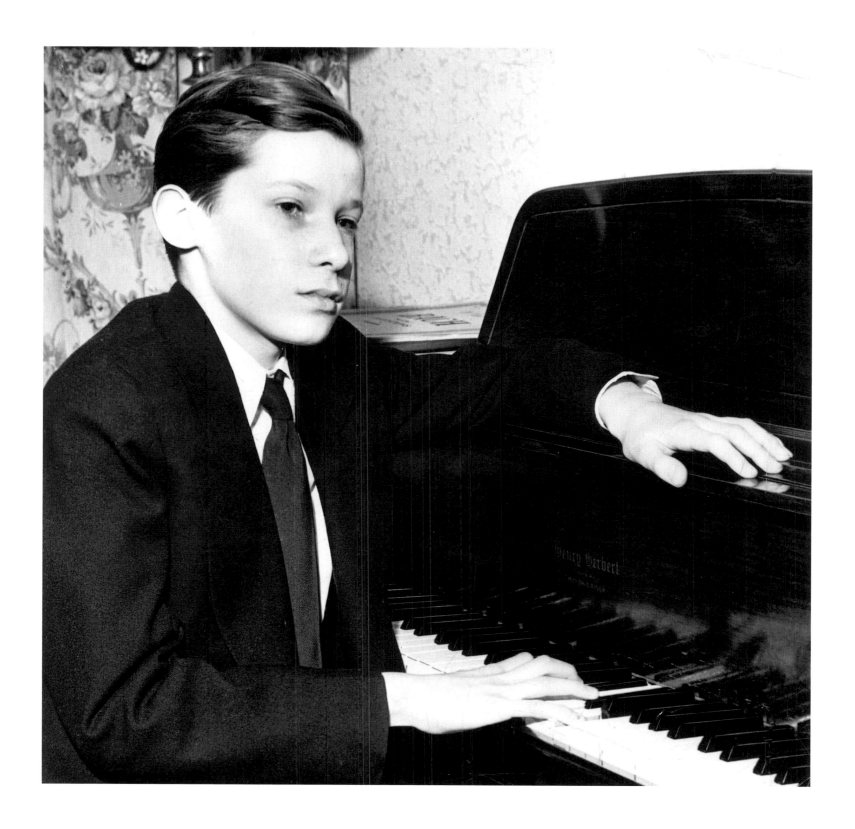

Glenn graduated from the Toronto Conservatory of Music in October 1946, just after he turned fourteen. (BELOW) Gould is in the top row, third from the left. He had already given several public recitals, at Kiwanis music festivals, in church and at his high school, Malvern Collegiate. His fame was spreading, even to England (RIGHT).

BUCKINGHAM PALACE

October 22nd. 1946.

The Lady-in-Waiting is commanded by The Queen to thank Mrs. Samuel Jeffrey for her letter and to say that Her Majesty was interested to read of the little Canadian boy who is such a clever musician.

Mrs. Samuel Jeffrey,
Port Perry,
Ontario,
Canada.

FIFTY-THIRD SEASON—1946-1947

MASSEY HALL
TRUSTEES:
J. S. McLean, Esq., Chairman
The Right Hon. Vincent Massey F. R. MacKelcan, Esq., K.C.
His Worship Mayor Saunders
G. Ross Creelman, Director

TUESDAY AND WEDNESDAY, JANUARY 14th and 15th, 1947

The Toronto Symphony Orchestra

Guest Conductor: BERNARD HEINZE

Guest Artist: GLENN GOULD, Pianist

Secondary School Concert

· PROGRAMME ·

GOD SAVE THE KING

"ADVANCE AUSTRALIA FAIR" (To be sung by the audience)

Australia's sons let us rejoice,
For we are young and free;
We've golden soil and wealth for toil,
Our home is girt by sea:
Our land abounds in nature's gifts
Of beauty rich and rare;
In hist'ry's page, let ev'ry stage
Advance Australia fair.
In joyful strains then let us sing Advance Australia fair.

Should foreign foe e'er sight our coast,
Or dare a foot to land,
We'll rouse to arms like sires of yore,
To guard our native strand:
Britannia then shall surely know,
Beyond wide ocean's roll,
Her sons in fair Australia's land
Still keep a British soul.

STEINWAY PIANO

OVERTURE, "FLYING DUTCHMAN" - - - - *Wagner*

CONCERTO IN G MAJOR, No. 4, OP. 58,
FOR PIANOFORTE AND ORCHESTRA - - *Beethoven*

Allegro moderato

Andante con moto

Rondo: Vivace

GLENN GOULD, *Pianist*

INTERMISSION

"NUTCRACKER" SUITE - - - - - *Tchaikovsky*

1. Miniature Overture
2. March
3. Dance of the Sugar Plum Fairy
4. Russian Dance (Trepak)
5. Arabian Dance
6. Chinese Dance
7. Dance of the Flutes
8. Waltz of the Flowers

INTERMEZZO — THE WALK TO THE PARADISE GARDEN, FROM
"A VILLAGE ROMEO AND JULIET" - - - *Delius*

DANCE AND POLKA, FROM "THE AGE OF GOLD" - *Shostakovich*

"BOLERO" - - - - - - - - *Ravel*

Next Secondary School Concerts

TUESDAY and WEDNESDAY, FEBRUARY 11, 12

ETTORE MAZZOLENI, Conducting

Guest Artist: JOSEPH PACH, Violinist

PROGRAMME	
Suite	*Purcell-Barbirolli*
Paris (Song of a Great City)	*Delius*
Overture, "Cockaigne" (In London Town)	*Elgar*
INTERMISSION	
Concerto for Violin and Orchestra	*Tchaikovsky*
Divertissement	*Ibert*

**Tickets for Single Concert Available to Students
on Evening of Concert at 40c Each**

In 1947, Glenn made his debut as soloist with the Toronto Symphony in Beethoven's fourth piano concerto. The headlines in the Toronto papers said it all: "He Played Beethoven Like a Master" *(Toronto Telegram)*; "Gould Displays Growing Artistry" *(Globe and Mail)*. He was poised for greatness.

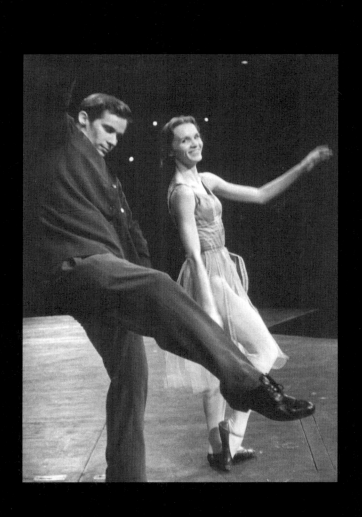

BURSTING FORTH

Glenn Gould whoops it up with a dancer on the Stratford (Ontario) Festival stage, probably in 1962.

Playing in the concert hall of the Toronto Conservatory of Music, 1956. In the early 1950s, Gould had toured western Canada giving recitals and performing with the Vancouver Symphony. He was the first pianist to perform on CBC television (1952) and, in 1954, performed with the Montreal Symphony. In January 1955, a week after his American debut in Washington, D.C., Glenn made his triumphant New York debut at Town Hall. The recital "started with something very slow [the Sweelinck *Fantasia*]," rememberd David Oppenheim of Columbia Records. Gould "set such a religious atmosphere that it was just mesmerizing. And it didn't take more than five or six notes to establish that atmosphere, by some magic of precise rhythm and control of the inner voices."

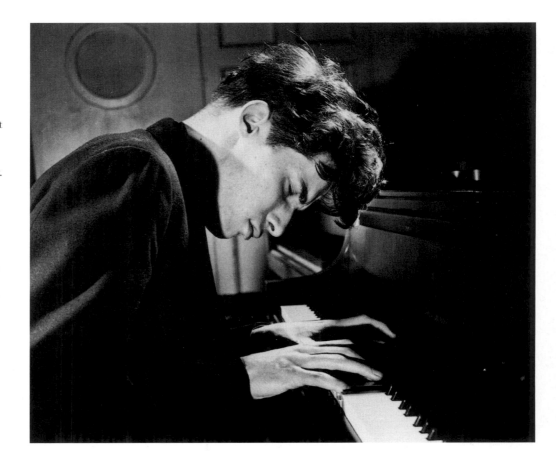

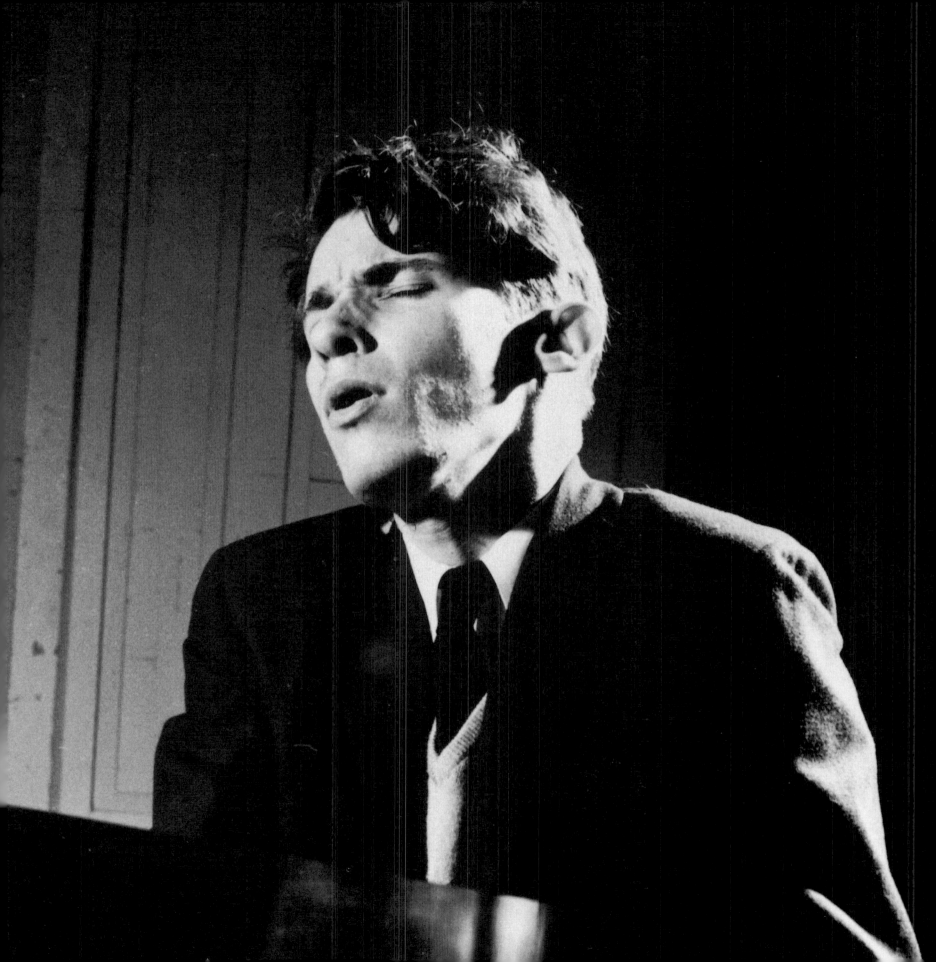

GLENN GOULD ✑ A Life in Pictures

"Suddenly you get a sound that no one has ever heard before . . . it's boney, it's taut . . . it is very rhythmical, it's clean, it's transparent. Here is a skinny scrawny guy from Canada who looks as if he is about to die by the time he comes on stage—so pale . . . he sits almost on the floor, he sings while he is playing. We've never [heard] anything like this. It's like, 'Where did this guy come from?'"

PETER ELYAKIM TAUSSIG

Recording Bach's *Goldberg Variations* in 1955 at Columbia's New York Studio.

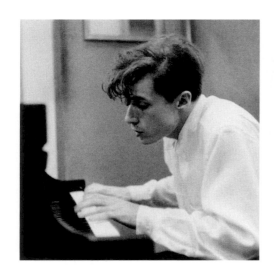 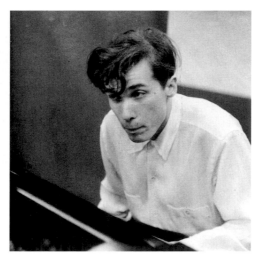

"The *Goldberg Variations* is music which observes neither end nor beginning, music with neither real climax nor real resolution. . . . It has, then, unity through intuitive perception, unity born of craft and scrutiny, mellowed by mastery achieved, and revealed to us here, as so rarely in art, in the vision of subconscious design exulting upon a pinnacle of potency."

<div align="right">GLENN GOULD</div>

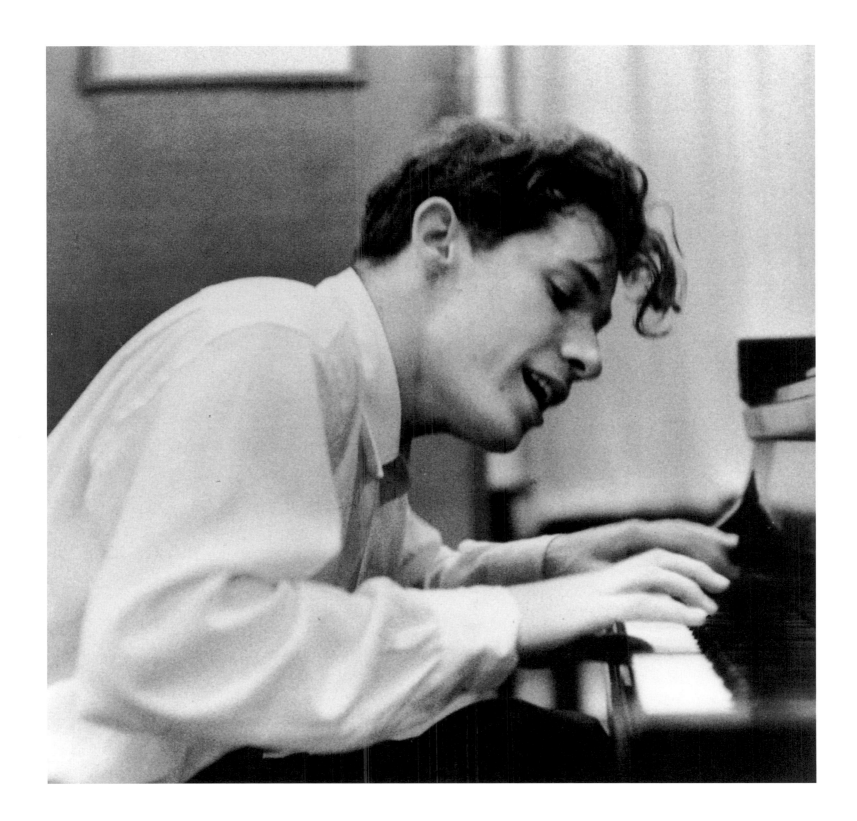

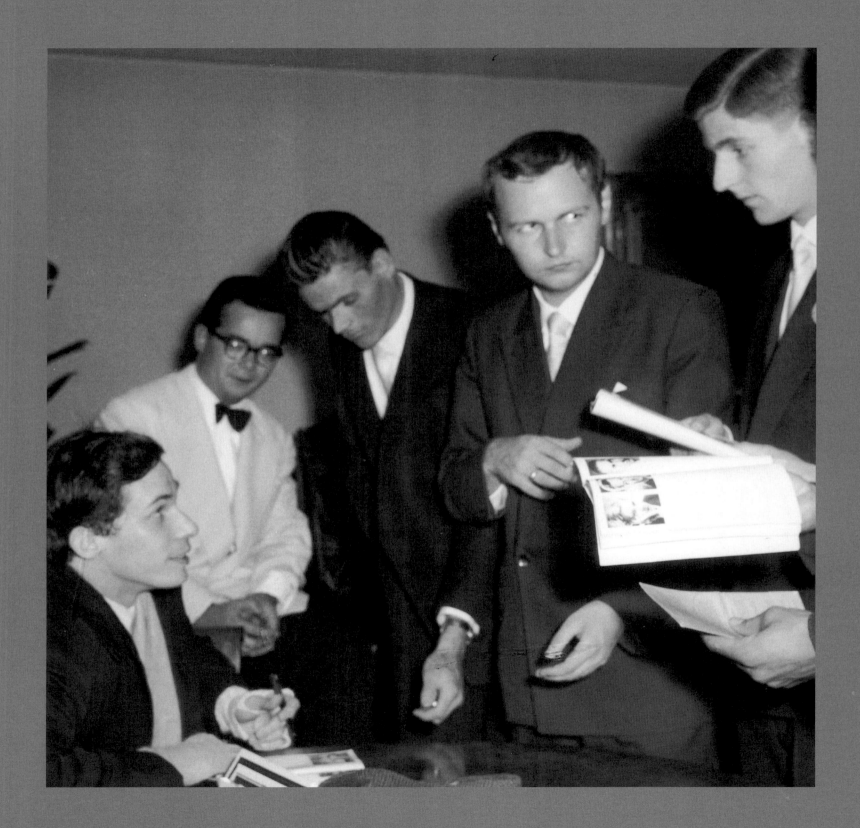

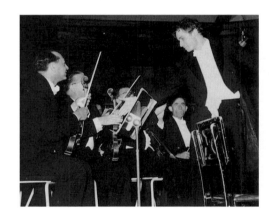

On tour. (OPPOSITE) Appearing happy and relaxed after a concert in Lucerne in August 1959, Gould signs autographs. He had just performed the Bach Concerto in D Minor with Herbert von Karajan conducting the Philharmonia Orchestra. (TOP RIGHT) Rehearsing Beethoven's Piano Concerto No. 2 with Sir Ernest MacMillan and the Toronto Symphony Orchestra at Massey Hall, May 1956. (CENTRE RIGHT) Shaking hands with the concert master of the Israel Philharmonic Orchestra after a performance in Jerusalem, December 1958. (BOTTOM RIGHT) Playing Beethoven's Piano Concerto No. 3 with the Utah Symphony, Salt Lake City, February 1959.

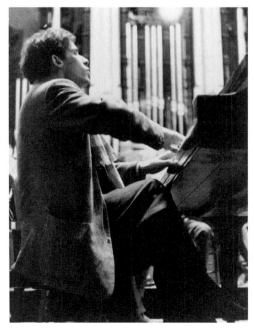

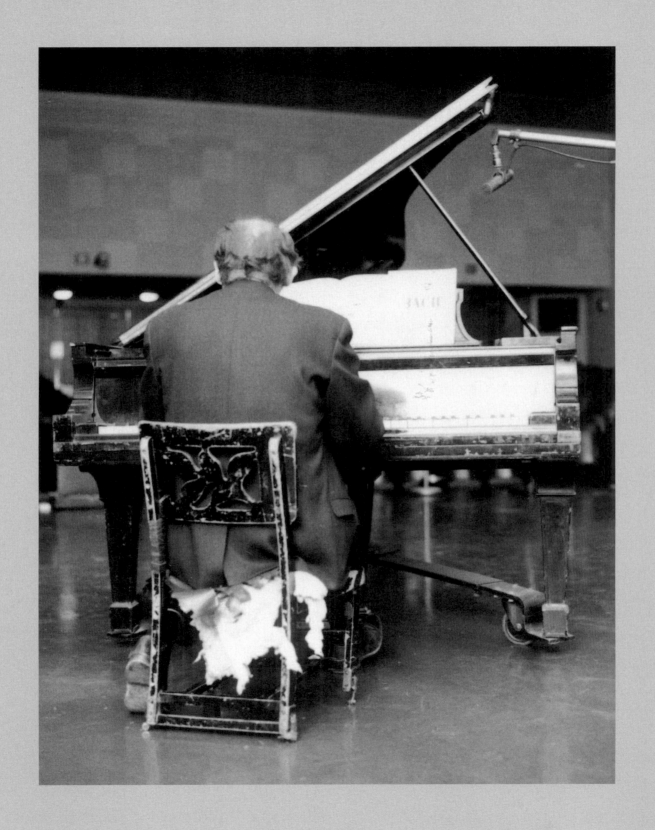

Because of Guerrero's teaching style, Glenn claimed that he could only play hunched over the keyboard. Bert Gould sawed off the legs of a high-backed wooden folding chair and tapped screws about three inches long into the feet. Glenn would then adjust the screws to a height that he felt was best. He took the chair everywhere with him. When the seat of the chair eventually disintegrated, Glenn continued to use it, playing while sitting on the empty frame.

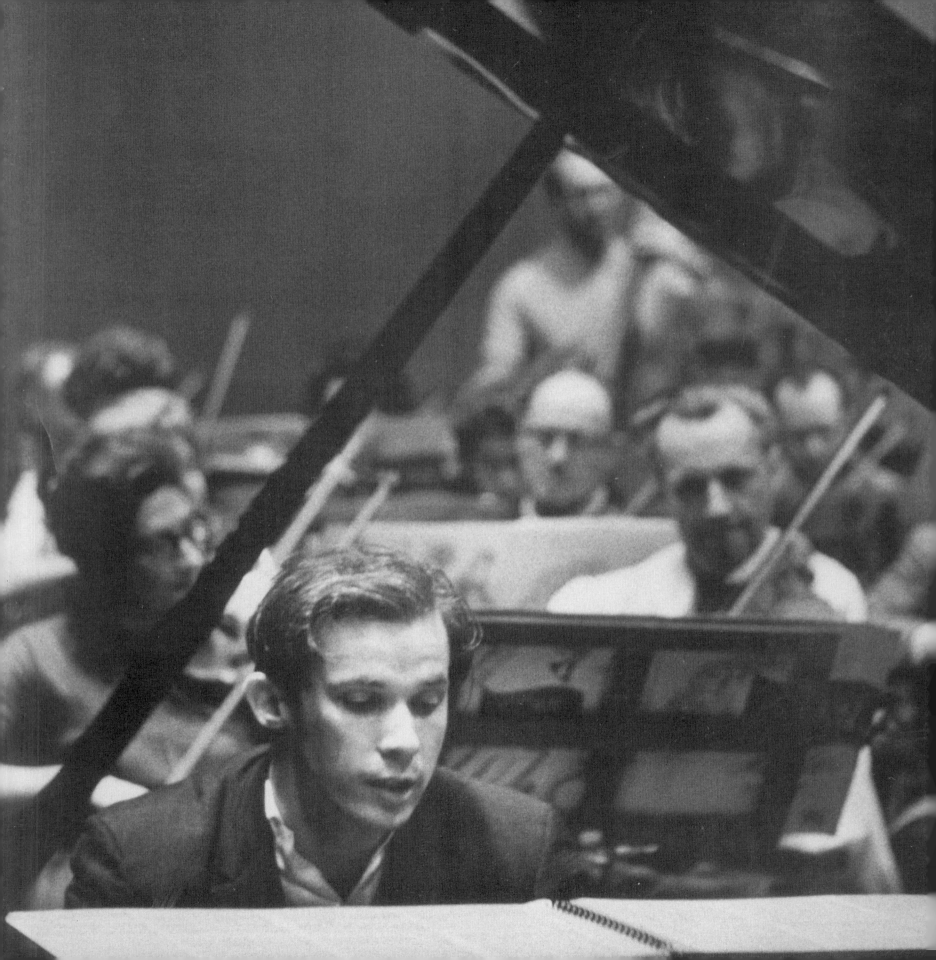

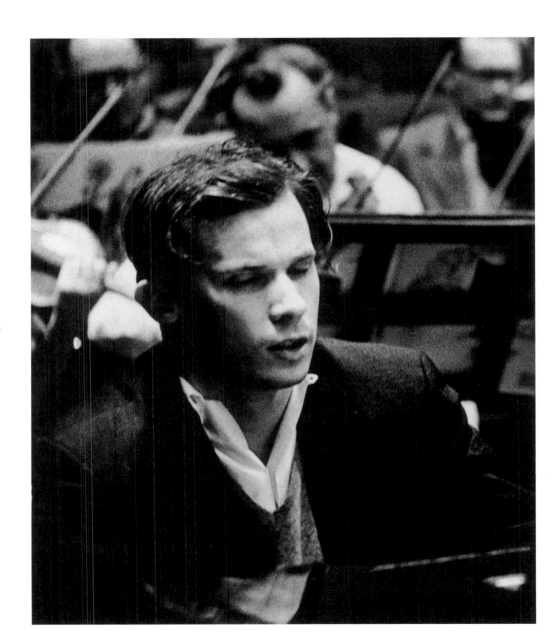

Playing piano during an orchestral rehearsal,
late 1950s.

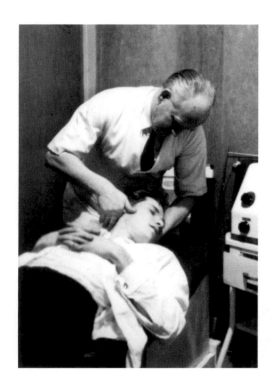

The stress of performing. (LEFT) Glenn was constantly plagued by health problems. He consulted many doctors, physiotherapists and chiropractors. The number of drugs he took was legendary. "I travel with pills for blood circulation, cold pills, vitamin pills, and a few others. . . . But this pill complex of mine has been grossly exaggerated. . . . One reporter wrote that I travelled with a suitcase full of pills. Actually, they barely fill a briefcase." Before performing, Gould would reduce the tension in his arms by soaking them in hot water. (OPPOSITE) Bathing his arms during the *Goldberg Variations* recording sessions, 1955.

Program cover for Glenn Gould's first concert in Russia, in Moscow on May 7, 1957. Gould's performances in the Soviet Union were the first leg of his first European tour. They were a total triumph. He gave recitals in Moscow and Leningrad, was soloist with the Moscow and Leningrad Philharmonics, and lectured to students at the Moscow and Leningrad conservatories.

Глен
ГУЛЬД
(Канада)

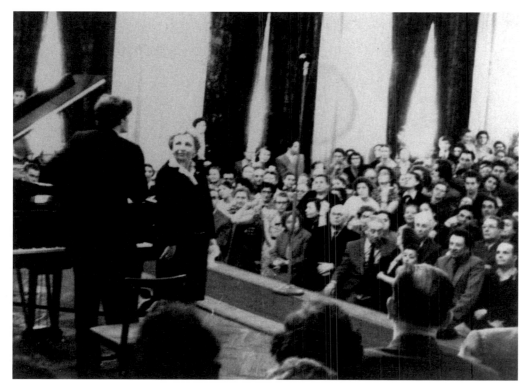

(ABOVE) An interpreter relays questions from the audience to Glenn at the Leningrad Conservatory, where he gave an informal lecture and recital before students and professors. (TOP RIGHT) Surrounded by his adoring audience after the recital. Gould was given an "unbelievable reception," wrote a Canadian official who attended one of the concerts, the audience showing its appreciation with short, staccato, almost deafening handclapping. Gould played the works of twentieth-century composers rarely heard in the Soviet Union—Berg, Schoenberg, Hindemith— to wide acclaim. (BOTTOM RIGHT) After a Moscow concert, with Sviatoslav Richter (on the right), a pianist whom Gould heard for the first time on this tour. Gould described Richter as "one of the most powerful communicators the world of music has produced in our time."

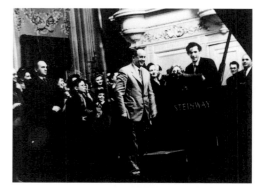

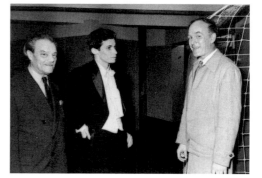

(OVERLEAF) Taking a bow after a Moscow performance.

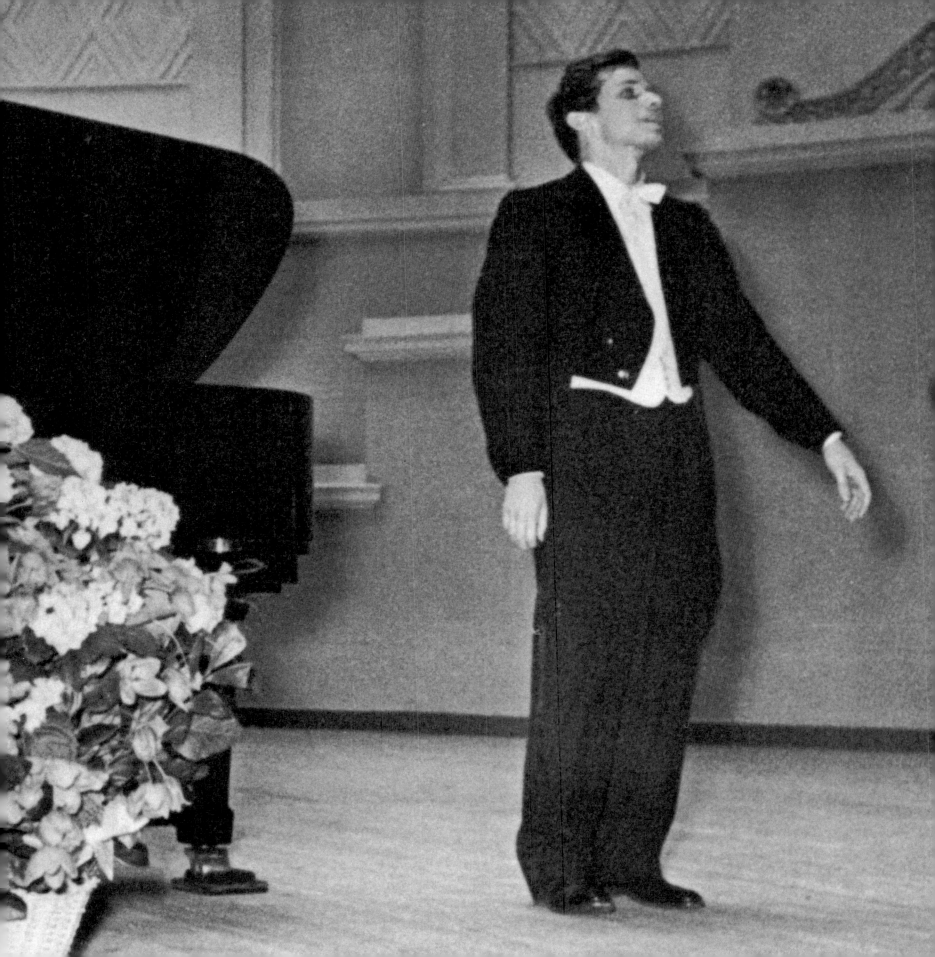

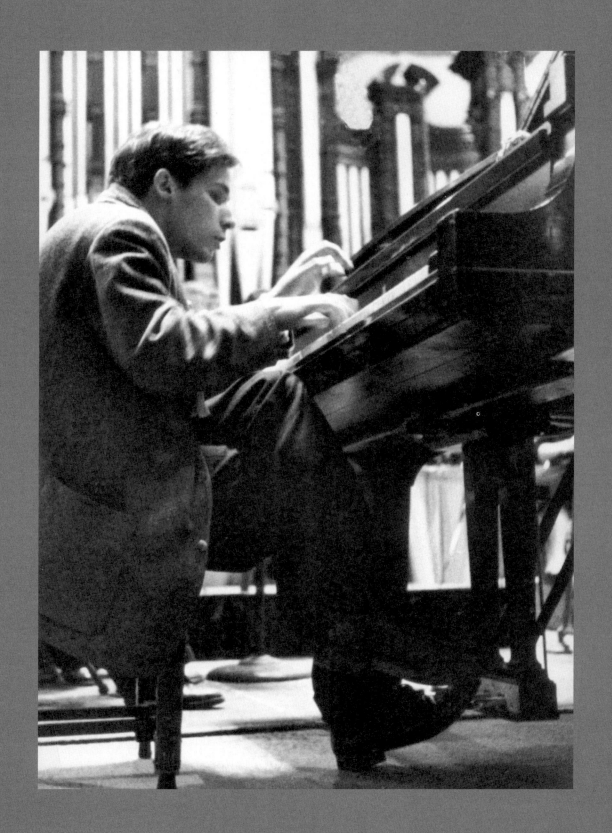

The emerging persona. Rehearsing with the Utah Symphony, Gould displays some of his characteristic traits: hunched over the piano; legs crossed while playing; eyes closed while listening to the orchestral passages; wearing a scarf and gloves indoors. "These aren't personal eccentricities," Gould wrote. "They're simply the occupational hazards of a highly subjective business."

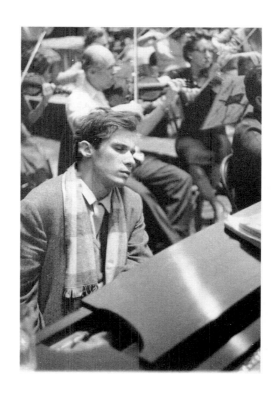

(OVERLEAF) Playing one of the four grand pianos at Columbia Records' New York studio, 1957. Glenn had the pianos moved from Steinway's basement storage to the studio so he might try them out under recording conditions.

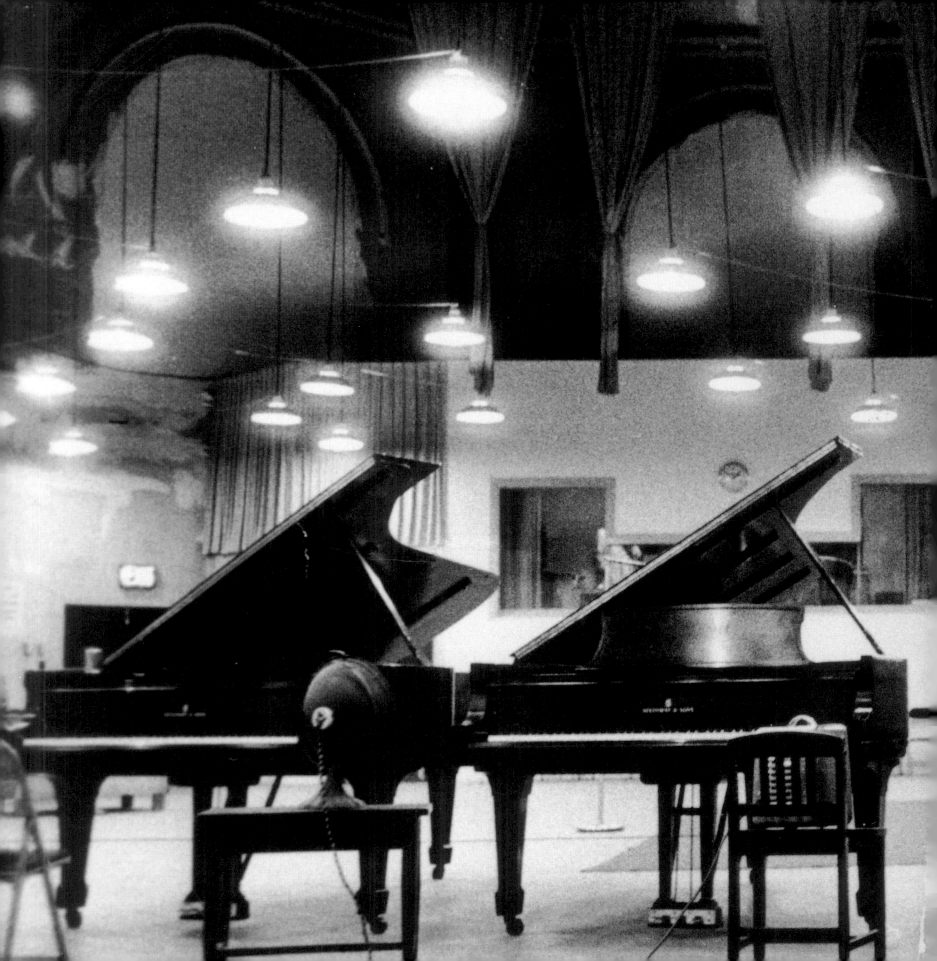

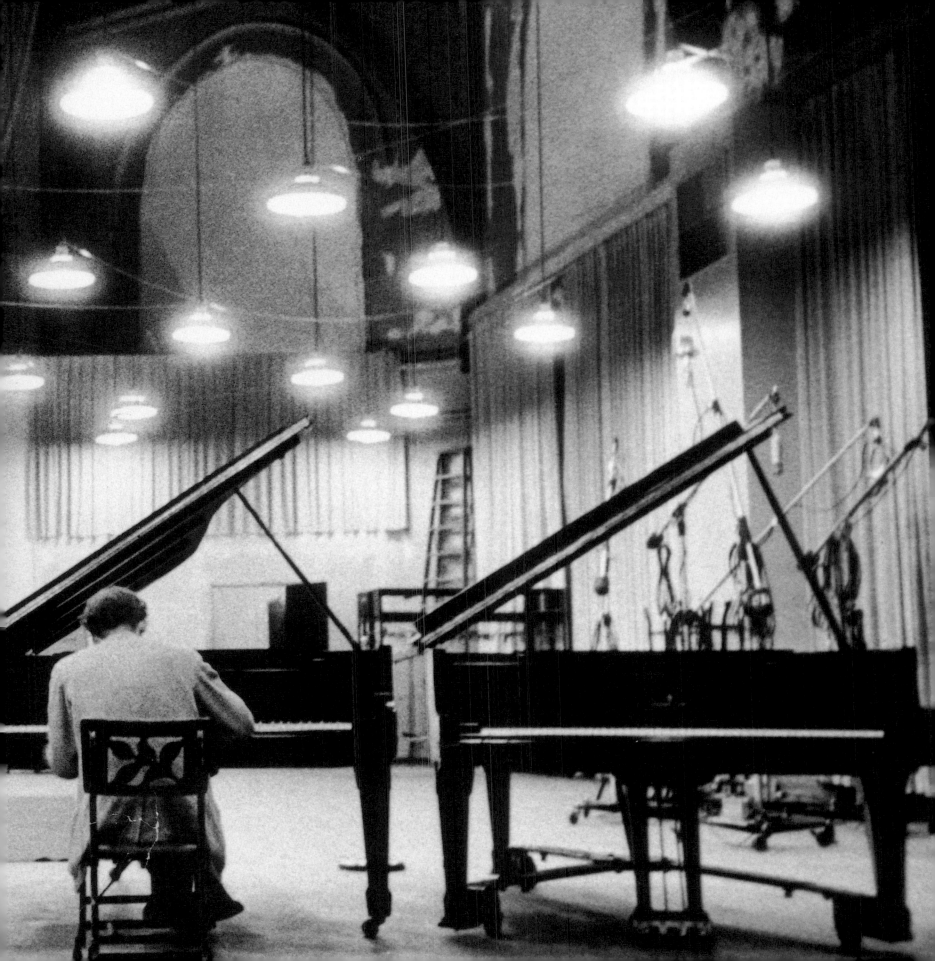

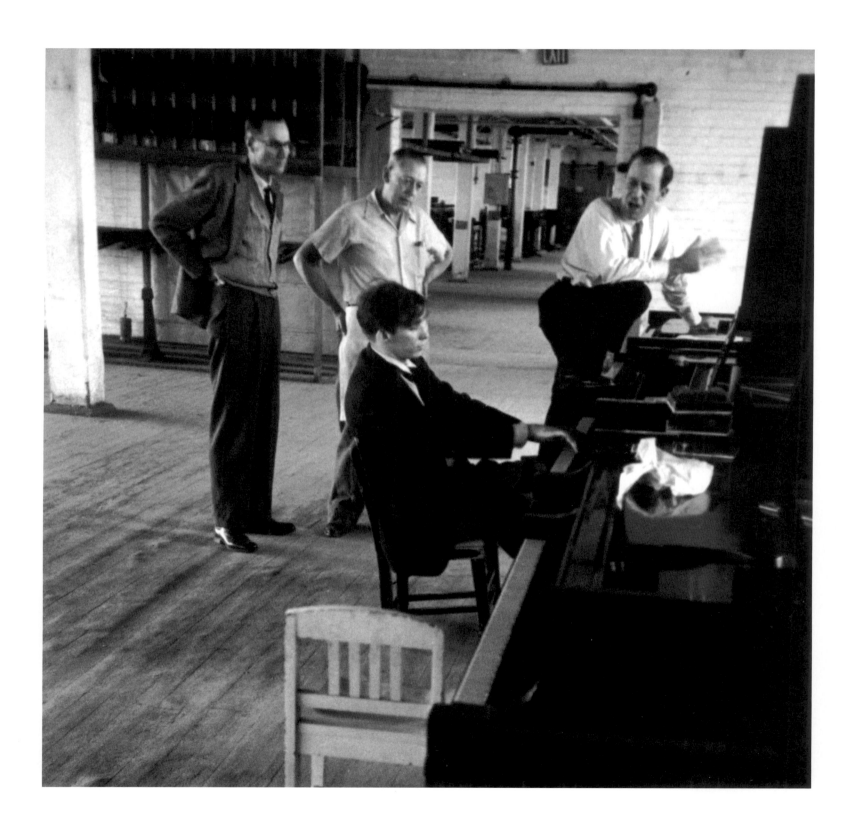

GLENN GOULD ✒ A Life in Pictures

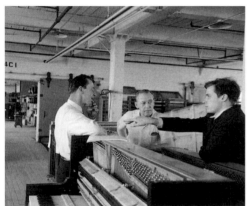

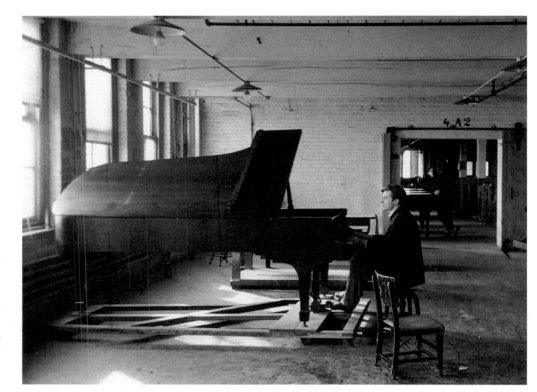

In 1958, photographer Don Hunstein accompanied Gould to the Steinway factory. "Glenn visited the Steinway factory in search of the ideal piano 'action' or striking mechanism. I tagged along, photographically speaking, as Glenn went gleefully from one piano to another, dragging Fritz Steinway and several technicians along with him." (In the photograph opposite, Fritz Steinway is on the far right.)

"It seems that I perform in the eighteenth and twentieth centuries and compose in the nineteenth. This must be jammed with psychoanalytic significance but I have never paid to find out what it means."

GLENN GOULD

Glenn always wanted to be a composer and even as a teenager was writing pieces for clarinet and piano. (ABOVE) Annotating a score at the cottage. (OPPOSITE) Working on the score of his string quartet. Written in the manner of the late Romantics, the quartet was recorded in 1960 as his Opus 1.

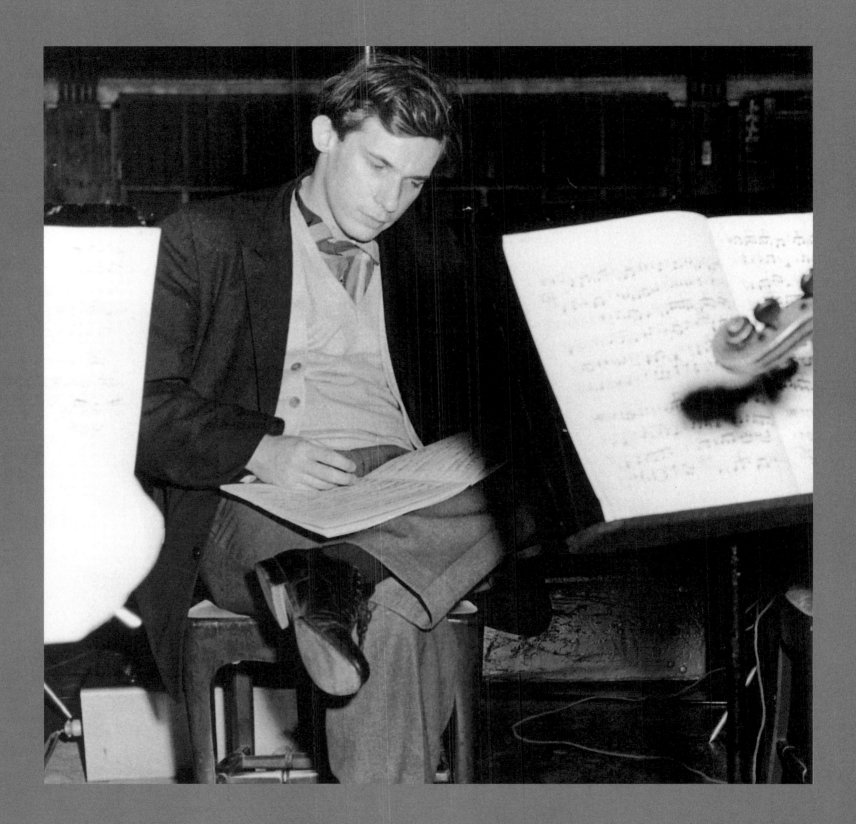

Glenn Gould in his twenties: Portraits of a musical genius.

GLENN GOULD ❧ A Life in Pictures

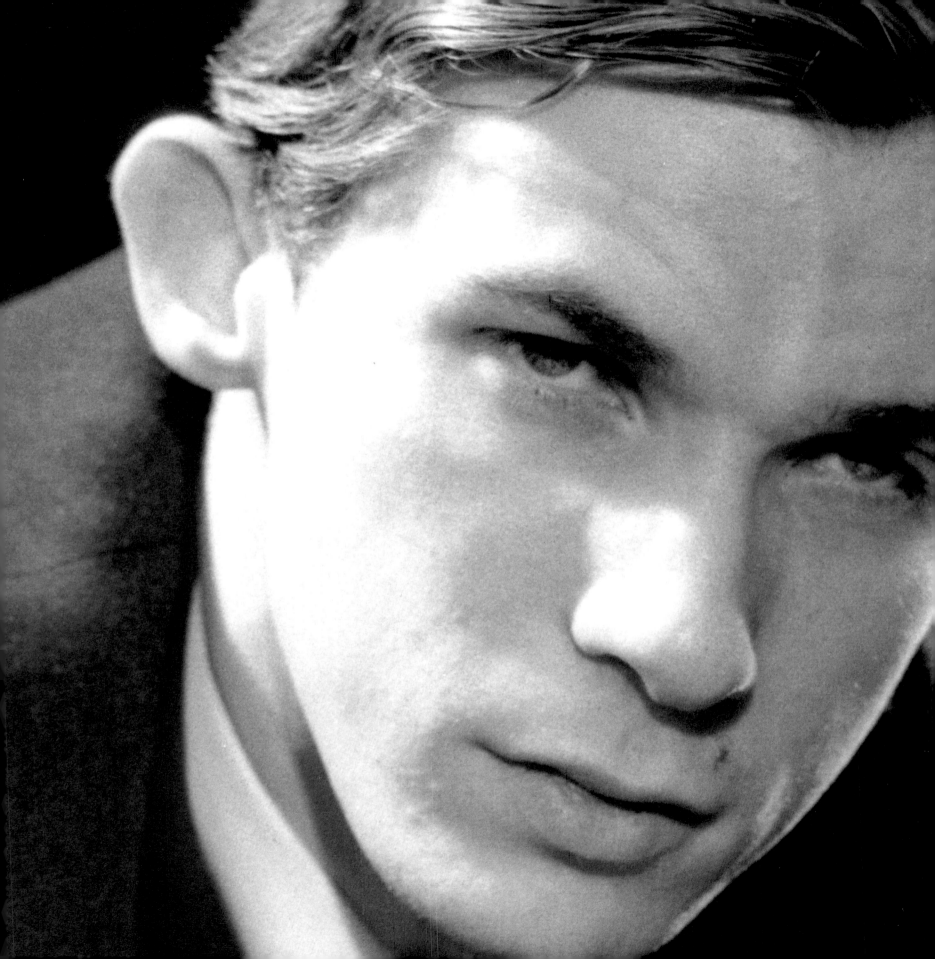

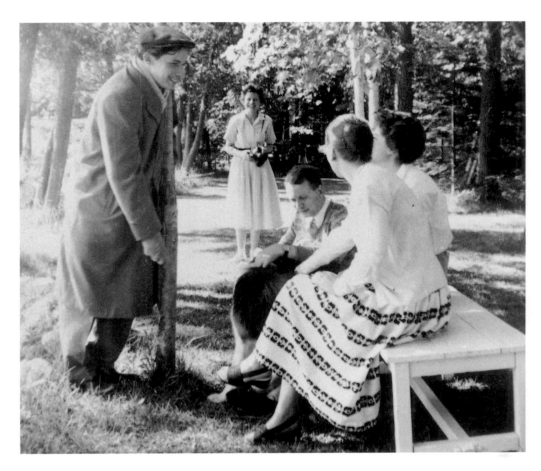

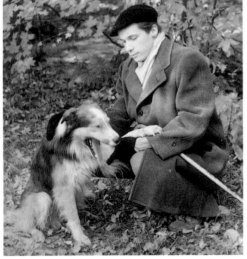

Interludes. (ABOVE) Chatting with friends, late 1950s. The man in the middle is John P.L. Roberts, who would later produce many of Gould's CBC radio documentaries. (LEFT) With his collie, Banquo. (OPPOSITE) Strolling along the shore of Lake Simcoe, late 1950s.

 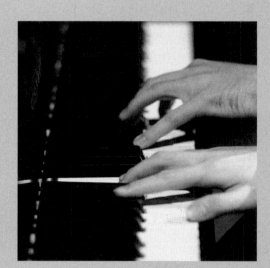

"Has anybody ever possessed ten fingers with ten such marvellously independent lives?"

TIM PAGE

In 1959, Glenn made two thirty-minute
documentaries for the National Film Board
of Canada: *Glenn Gould Off the Record*
and *Glenn Gould On the Record*. (RIGHT)
Recording Bach's *Italian Concerto* at the
Columbia Records studios for *On the Record*.
(OPPOSITE) Sharing a lighter moment on the
set. What often "saved [Glenn] from [his own
eccentricities] was a wonderful sense of
humour." (Robert Silverman)

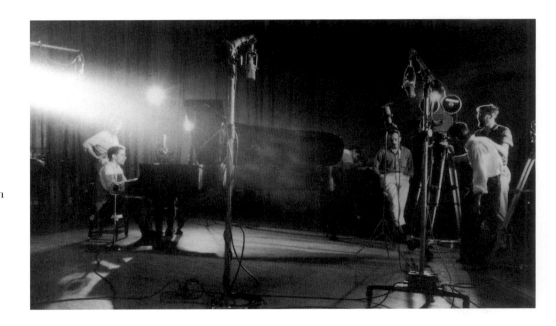

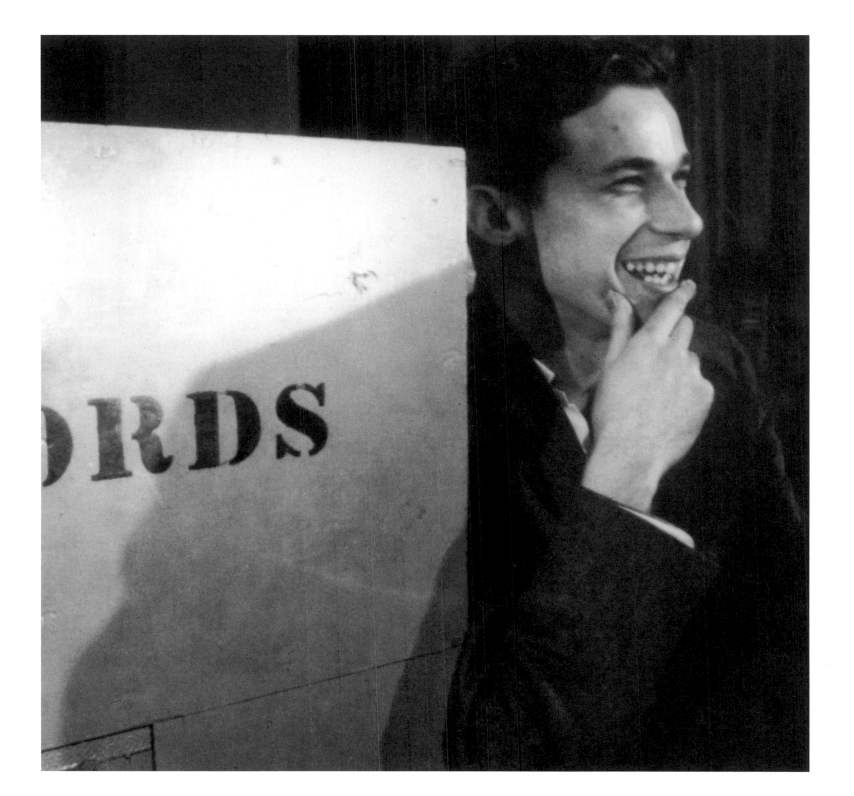

Gould at Stratford. From its inception in 1953, music was integral to the Stratford (Ontario) Shakespearean festival. Glenn played in its first season: "The concerts . . . were one of the minor miracles of Stratford and, in spite of leaky dressing rooms, a prevailing humidity to which even I responded by playing in shirt sleeves, a miserable instrument and no organization whatsoever, there was already the intimation that music somehow belonged to this theatre, and could, perhaps, grow in a very special way." In 1956 Gould was invited to be a co-director of the new musical programs at the festival. (RIGHT AND OPPOSITE) Glenn rehearsing with the festival orchestra in July 1956.

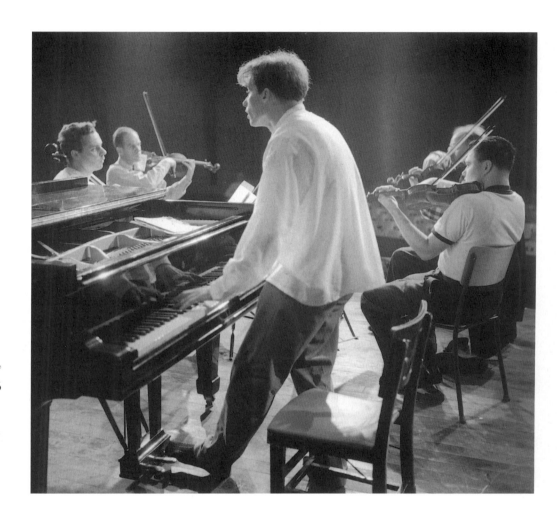

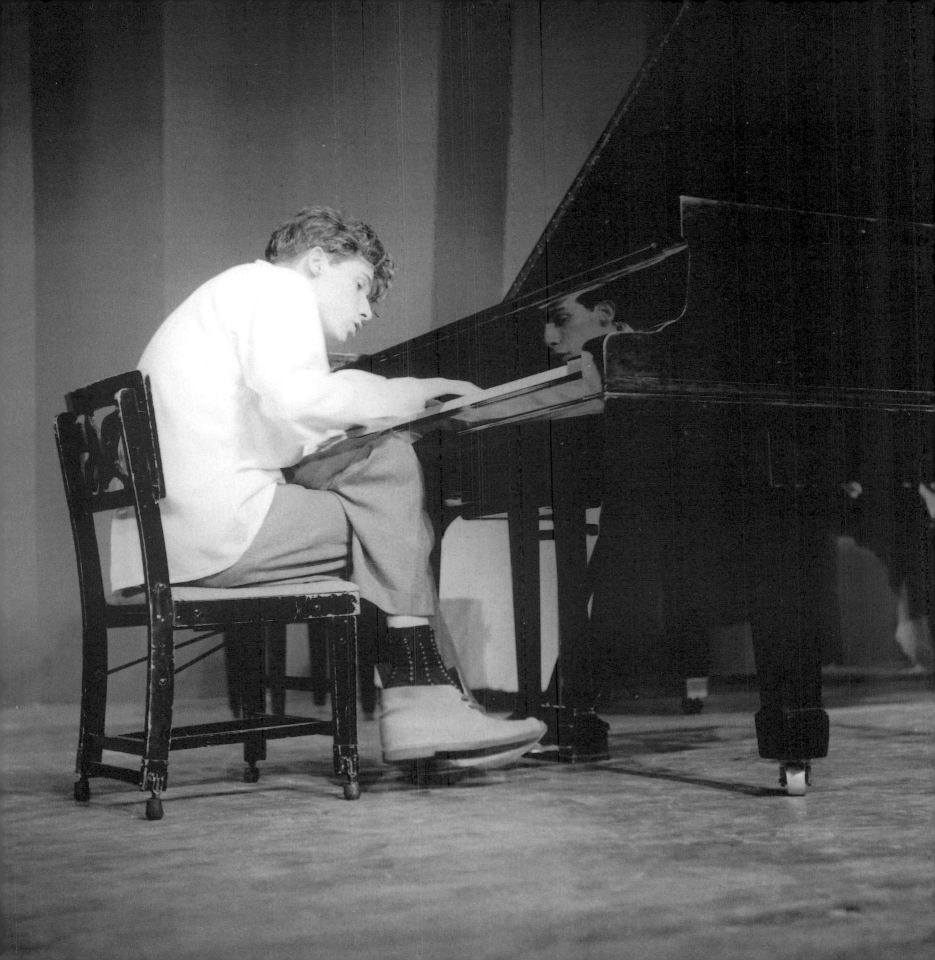

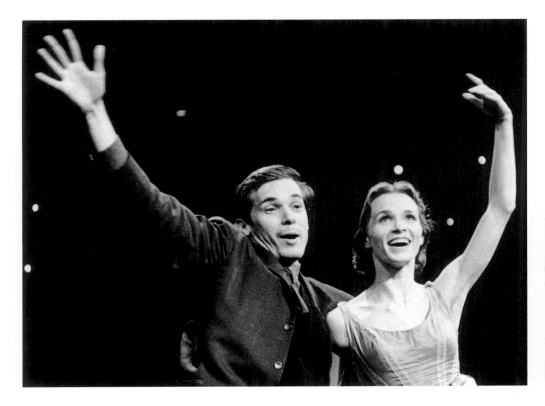

Gould continued to appear at Stratford until 1964. (ABOVE) With a dancer on the Stratford Festival stage, 1962. (RIGHT) During a 1960 rehearsal. (OPPOSITE) Taking a bow in his tweed coat, after performing a Bach concerto, summer 1960.

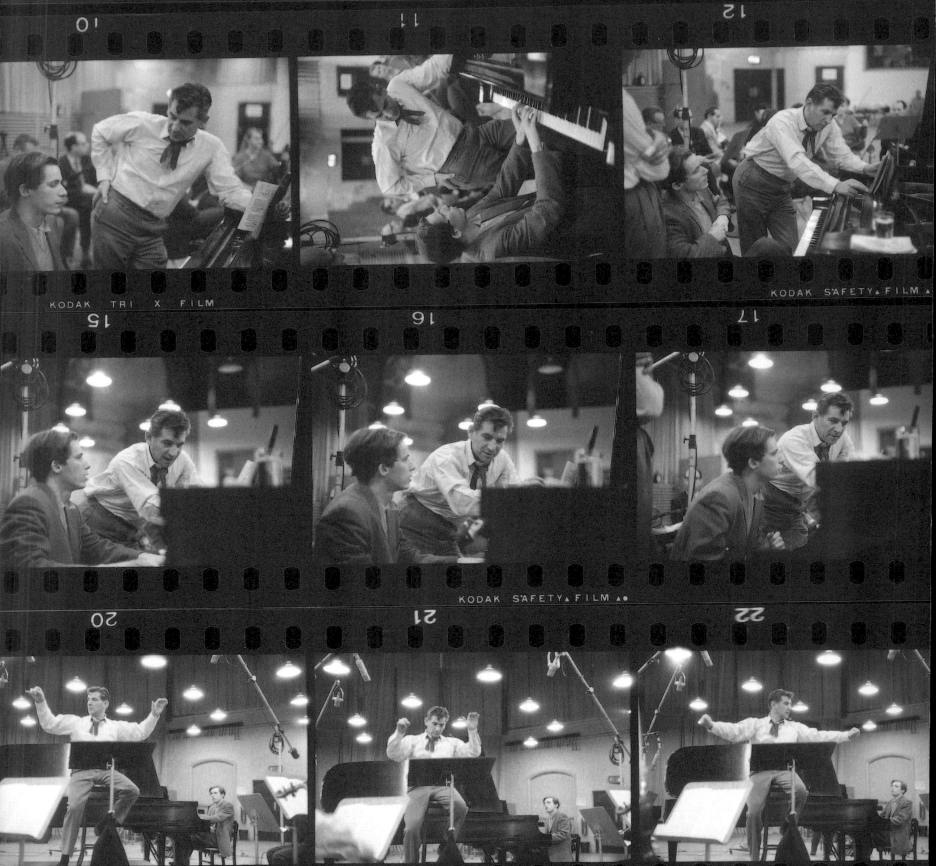

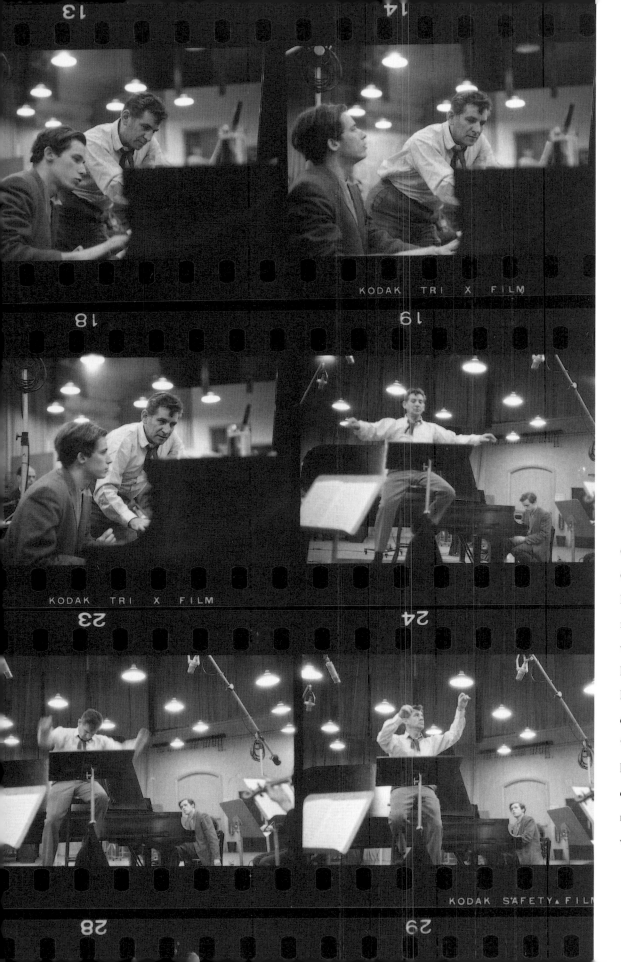

Gould recorded primarily for one label—Columbia (later Sony Classical)—for which he made more than 90 records. Here, he is recording Beethoven's Piano Concerto No. 2 with Leonard Bernstein, April 1957. Gould had performed the concerto live with Bernstein and the New York Philharmonic earlier that year. Bernstein said of Gould, "He gives me a whole new interest in music," later adding, "He had an intellect that one could really play against and learn from . . . I never felt he was my junior in any sense. He was a real peer in every sense."

Recording Beethoven's Piano Concerto No. 1
with Vladimir Golschmann and the Columbia
Symphony, April 1958.

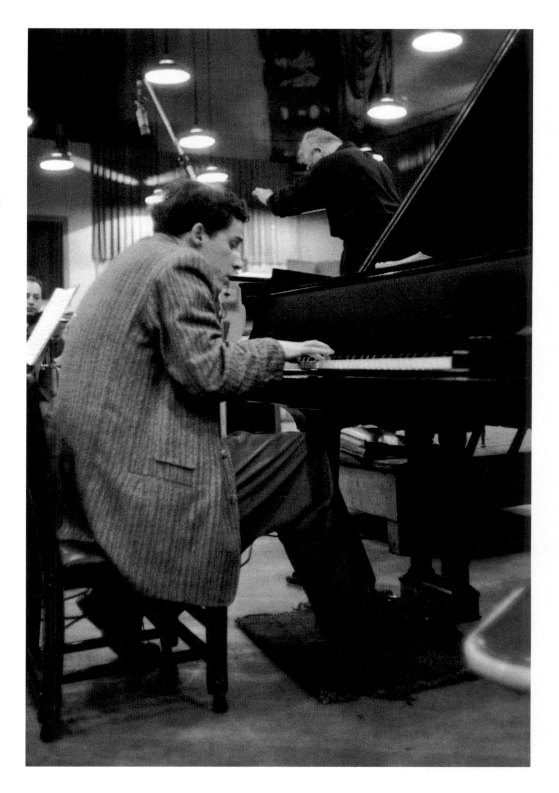

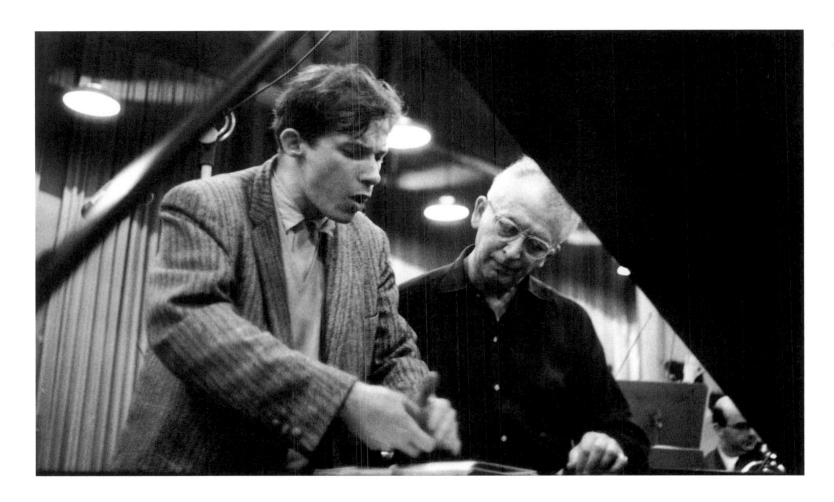

"I have been exulting for two days now in our Beethoven #1," Gould wrote to Golschmann. "I hope you have heard it and are as proud of it as I am. There is a real joie de vivre about it from beginning to end. Usually I become disenchanted with any new recording . . . but I have now listened to it about six times and like it better on each occasion."

GLENN GOULD ❧ A Life in Pictures

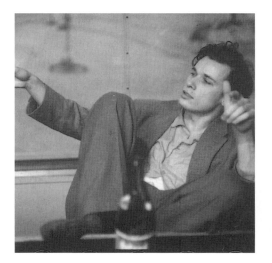
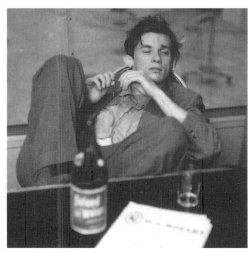

Listening to a playback of Haydn's Piano Sonata in E-flat Major, January 1958.

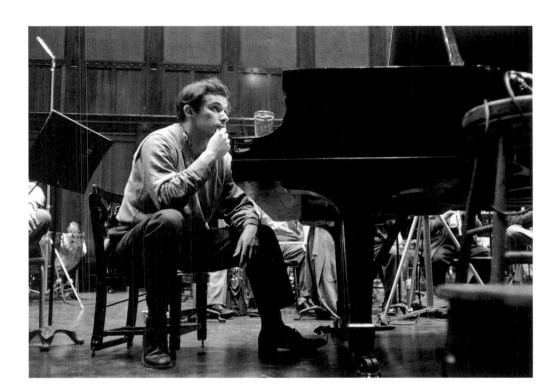

Recording the Schoenberg Piano Concerto in Toronto's Massey Hall, Robert Craft conducting, January 1961. It was at this session that Gould first saw the possibilities of recording over live performance.

"[The producer] would get a phone call saying, 'We need to do an insert starting two bars after letter "L"' . . . [the producer] had the most extraordinary ability to recall precisely what the musical context was within which that insert would have to be fit. . . . The ability to do that was something that I have never seen in any other artist. And I thought, 'Damn it, I'm going to learn to do this.' Because that's what recording is all about."

GLENN GOULD

An unusual recording from October 1961. The piece was Richard Strauss's *Enoch Arden*, his musical setting of Tennyson's long poem. Claude Rains read the poem accompanied by Gould. Mrs. Rains, who was present at the recording, was concerned that the two collaborators would distract each other and insisted that they be separated, each surrounded by a series of screens.

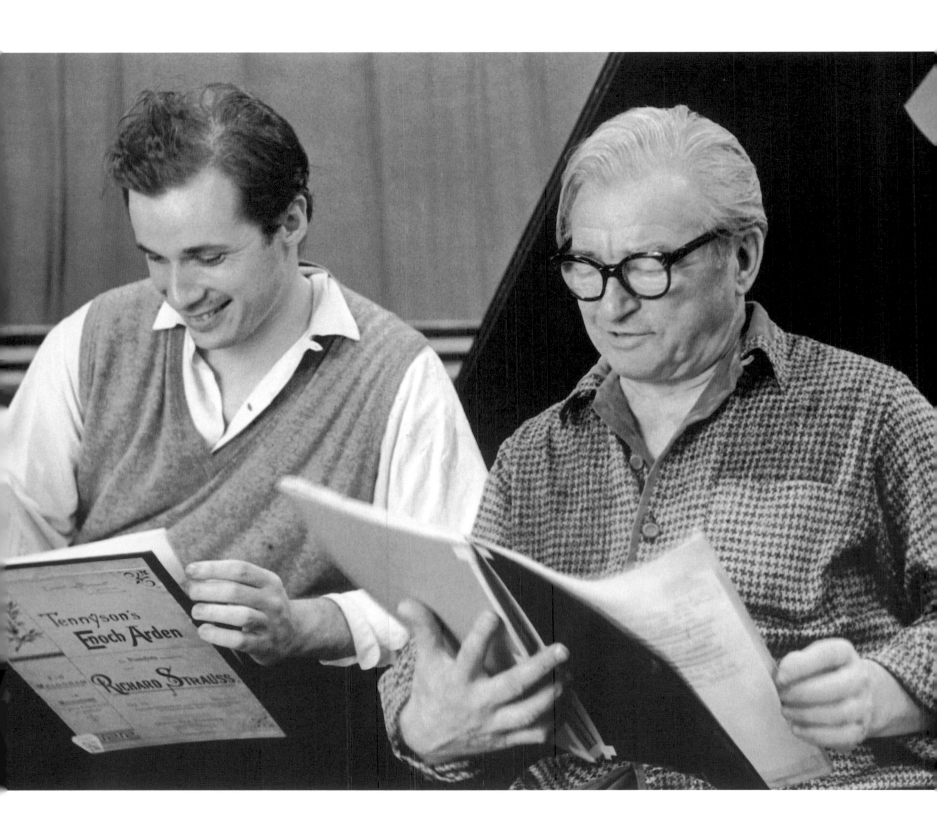

In 1960–61, Gould made five television programs for the CBC, including the documentary, *Richard Strauss: A Personal View.* Accompanying Glenn were violinist Oscar Shumsky, in the first movement of Strauss's Sonata for Piano and Violin, and soprano Lois Marshall, who sang Strauss's *Ophelia Lieder.* Gould was a great admirer of Strauss. He hailed the composer's *Capriccio* as the greatest opera of the twentieth century and would play the orchestral parts of the overture and last scene of the work from memory—there was no transcription—and if the fingering was too complicated, he would sing those sections.

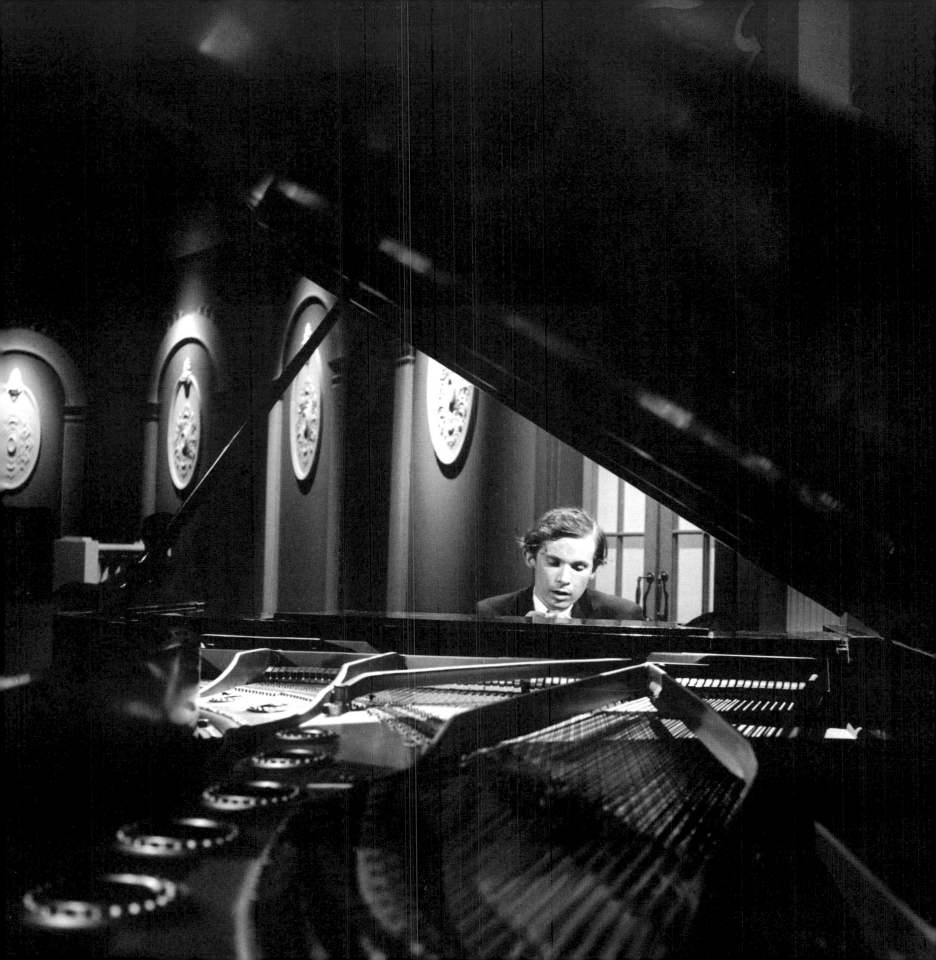

The organ was a great influence on Gould, particularly on the way he approached the piano. As a boy, Gould would play the organ in church on Sunday evenings. "Those moments of Sunday evening sanctuary became very special to me. They meant one could find a certain tranquility—even in the city—but only if one opted not to be part of it."

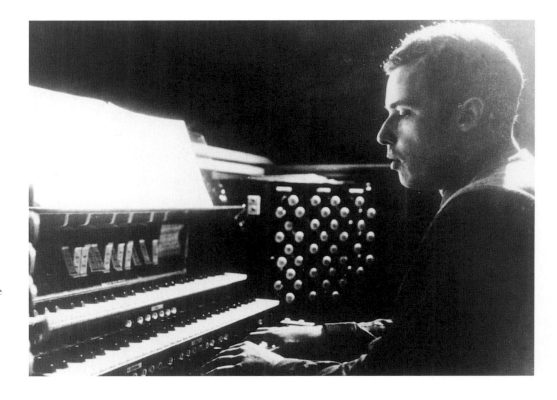

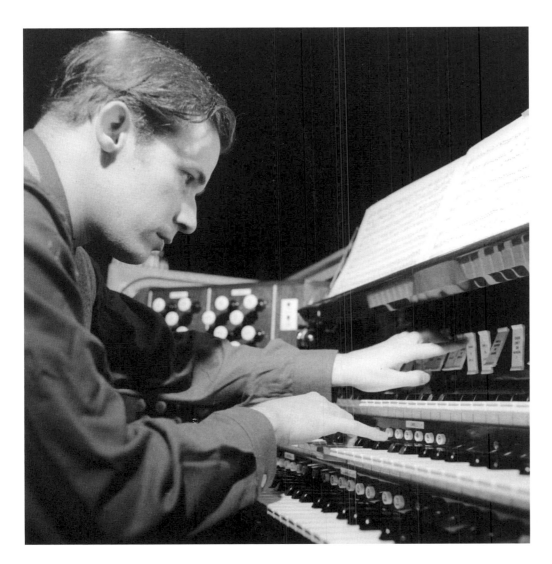

"I don't go to church much these days . . . but I do repeat that phrase to myself very often— the one about the peace that the earth cannot give—and find it a great comfort."

GLENN GOULD

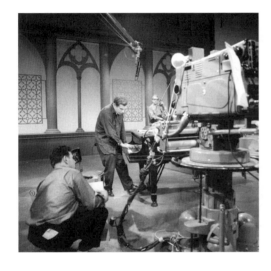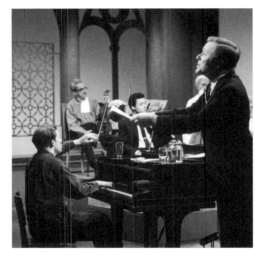

Glenn Gould on Bach, another CBC-TV broadcast from 1962. (OPPOSITE) Glenn opened the
show by playing on organ an excerpt from Bach's "St. Anne" Fugue. (ABOVE LEFT) Glenn
conducts from a piano—not his own—that he described as "a neurotic piano that thinks it is
a harpsichord." (ABOVE CENTRE) Gould conducts the soloist, countertenor Russell Oberlin, in a
Bach cantata. "For Bach, the contrapuntal style . . . was a way in which to define musically the
life of the spirit, and that for him, a texture which brought together and unified many diverse
elements was best of all able to glorify God." (Glenn Gould)

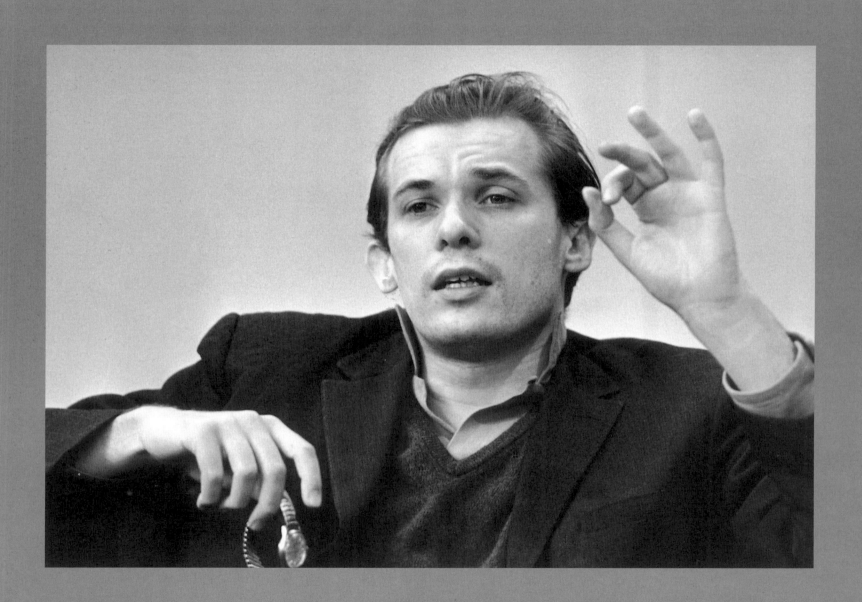

"The great thing about the music of Sebastian Bach is that it . . . transcends all of the dogmatic adherences of art . . . all of the frivolous effete preoccupations of aesthetics. It presents to us an example of a man who makes richer his own time by not being of it. . . . It is an ultimate argument . . . that man can create his own synthesis of time without being bound by the conformities time imposes. . . ."

GLENN GOULD

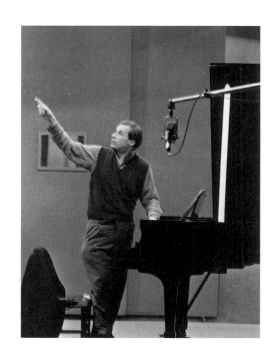

Recording the Bach Partitas, New York, March 1963.

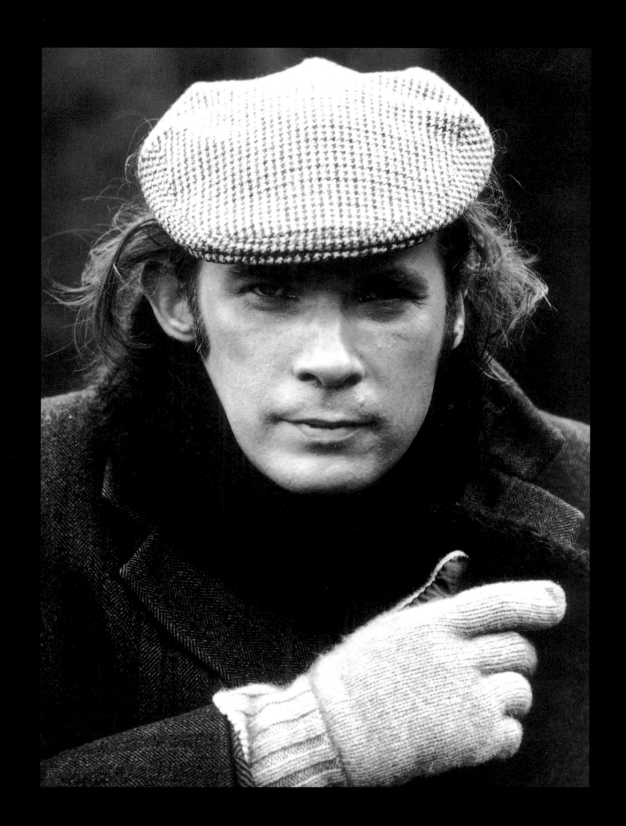

NEW HORIZONS

Portrait, April 1974.

Glenn Gould gave his last public perform-
ance, in Los Angeles, in April 1964. In June,
when the University of Toronto presented him
with an honorary doctorate, in his convoca-
tion address he made an argument for
recorded music in the electronic age: "It is
my firm conviction that the concert experi-
ence . . . will not likely outlive the twentieth
century . . . [it] is being cultivated so exclu-
sively for its museum potential that however
worthy that may be, one can no longer con-
sider it too seriously in relation to the signifi-
cant trends of art in our time. . . . The rela-
tionship between music and the various
media of electronic communication is the key
to the future not only of the way in which
music will appear or be encountered, but also
the key to the manner in which it will be per-
formed and composed."

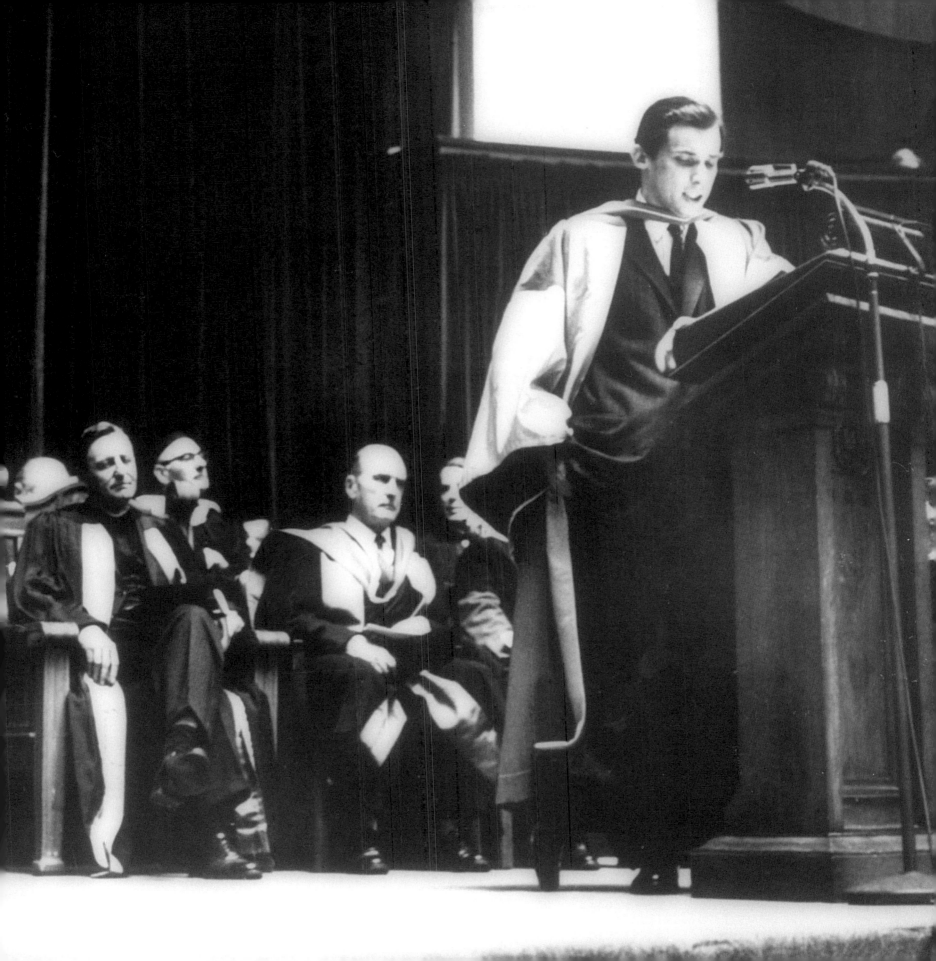

Music in the electronic age.

(FAR LEFT) Tinkering with his tape
recorder—Glenn was one of the first to own
one in Toronto—at the cottage, circa 1956.
(LEFT) With his equipment in a CBC studio.
(OPPOSITE) In a television studio, with photos
from the 1955 *Goldberg Variations* sessions
showing on the monitors, 1980.

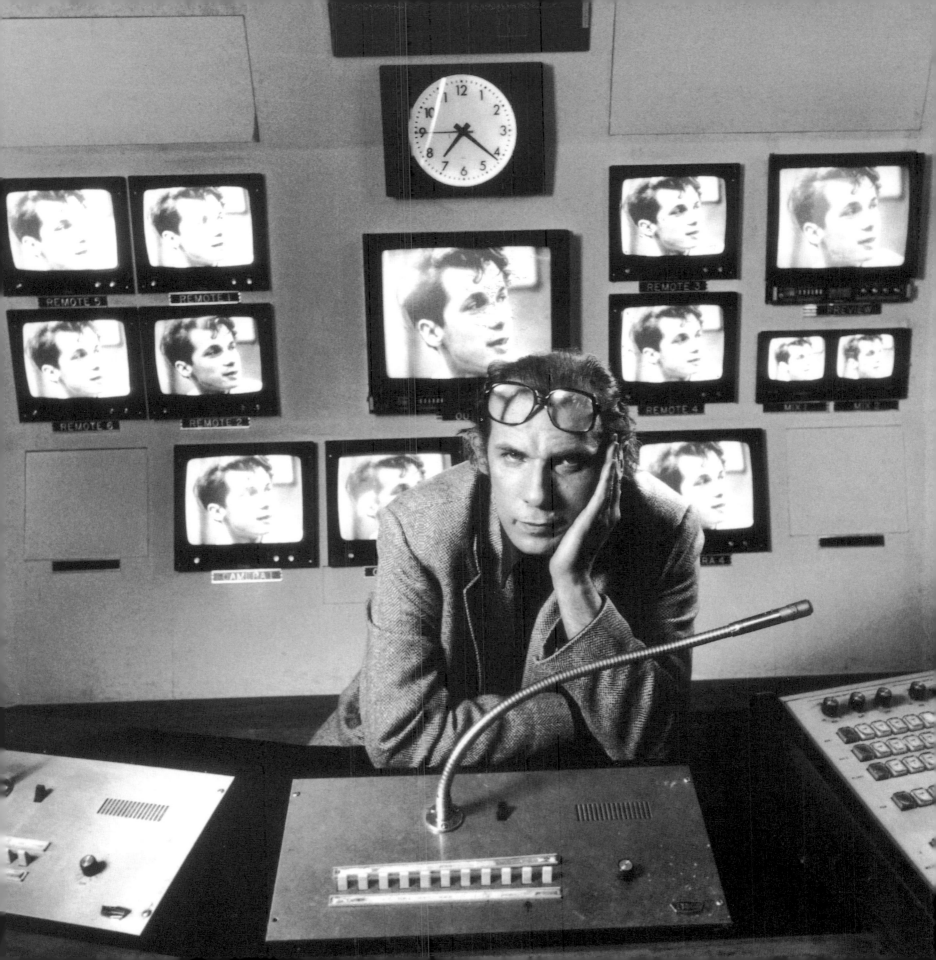

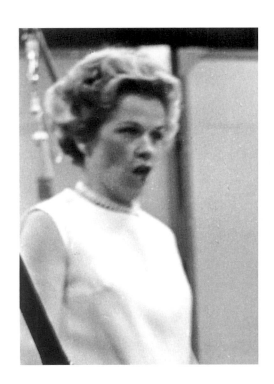 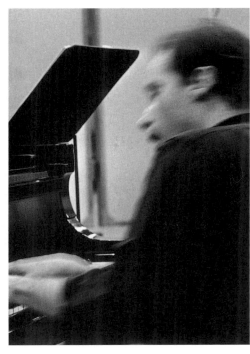

From his retirement from the concert stage
until his death, Glenn recorded constantly.
Here, with Helen Vanni, recording
Schoenberg's "The Book of the Hanging
Gardens," September 1964.

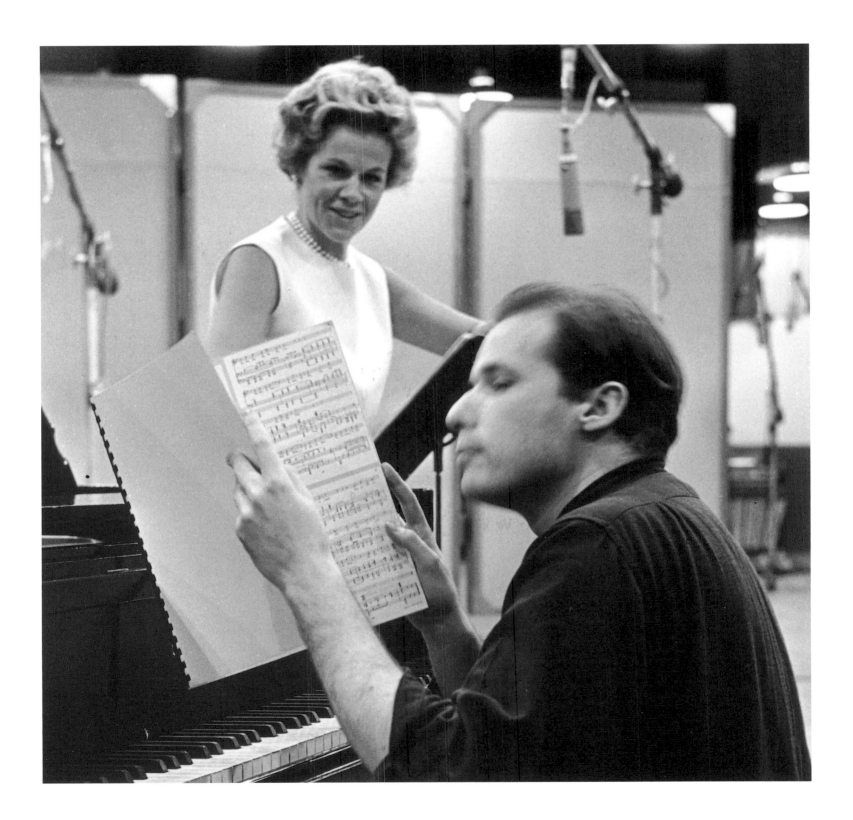

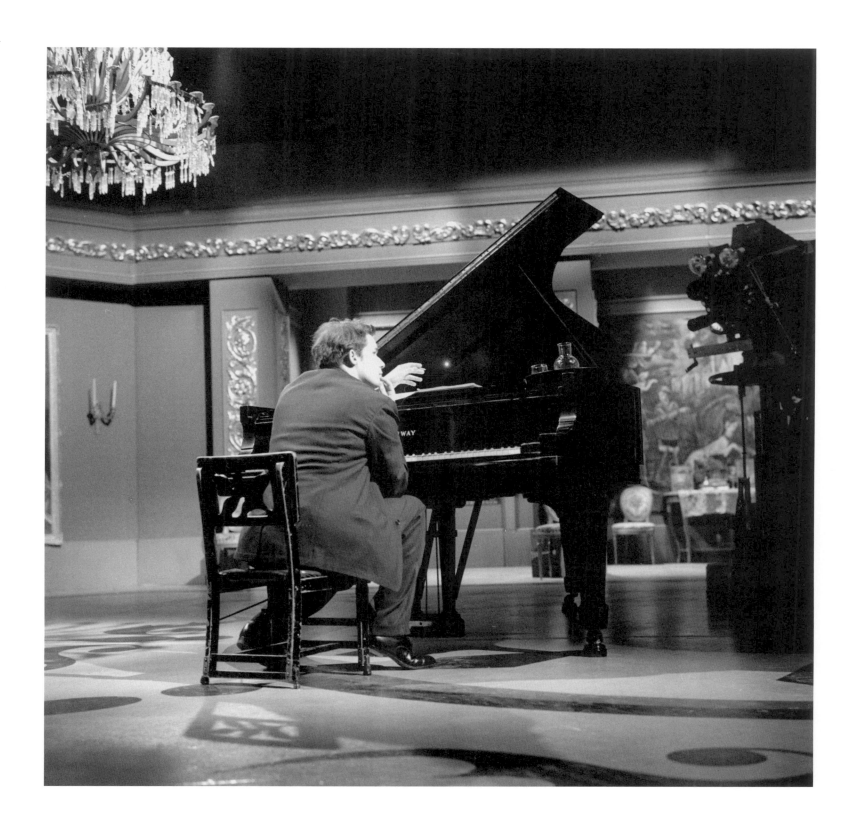

GLENN GOULD ⌘ A Life in Pictures

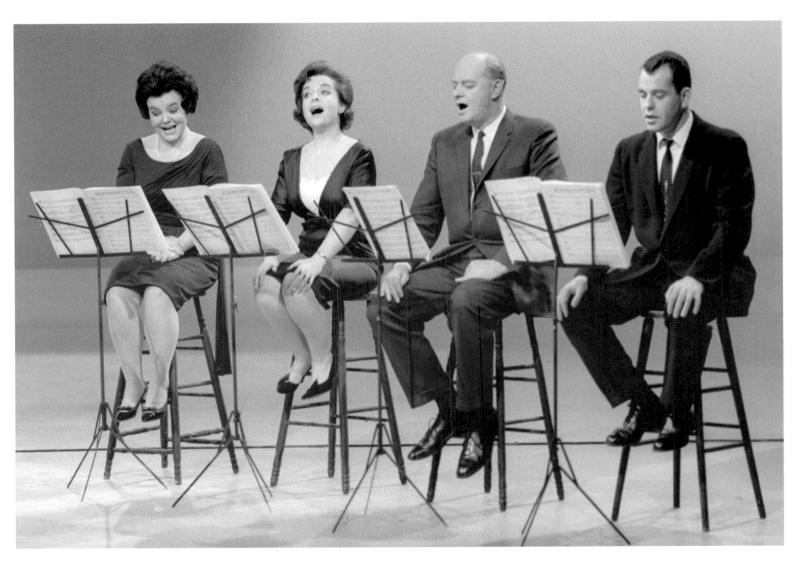

The well-tempered television performer. In 1963, on CBC Festival's *The Anatomy of the Fugue*, Gould presented the television premiere of his composition "So You Want to Write a Fugue?," a tongue-in-cheek treatment for four voices and string quartet of his favourite contrapuntal form. Gould conducts Lillian Smith Weich, Patricia Rideout, Gordon Wry and Edgar Murdoch.

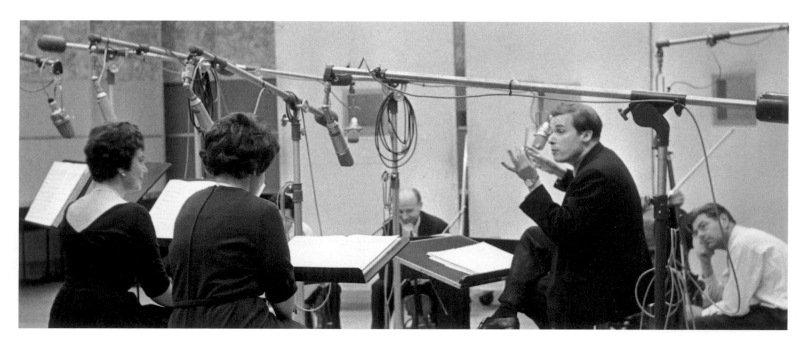

In 1963 Columbia recorded "So You Want to Write a Fugue?" with Glenn conducting the Juilliard String Quartet.

So you want to write a fugue?

You've got the urge to write a fugue,

You've got the nerve to write a fugue.

So go ahead and write a fugue that we can sing!

———

But never be clever for the sake of being clever,

For a canon in inversion is a dangerous diversion,

And a bit of augmentation is a serious temptation,

While a *stretto* diminution is an obvious solution.

Never be clever for the sake of being clever,

For the sake of showing off!

Music and lyrics by Glenn Gould. © 1964 G. Schirmer Inc.

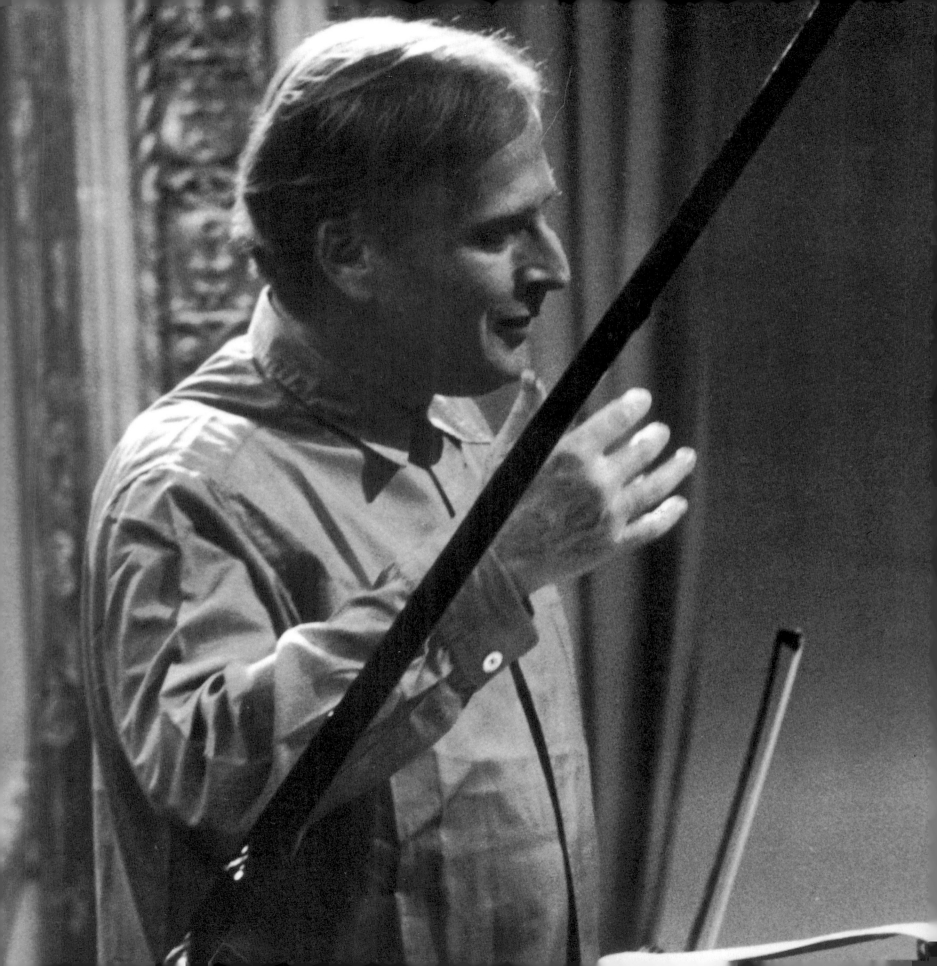

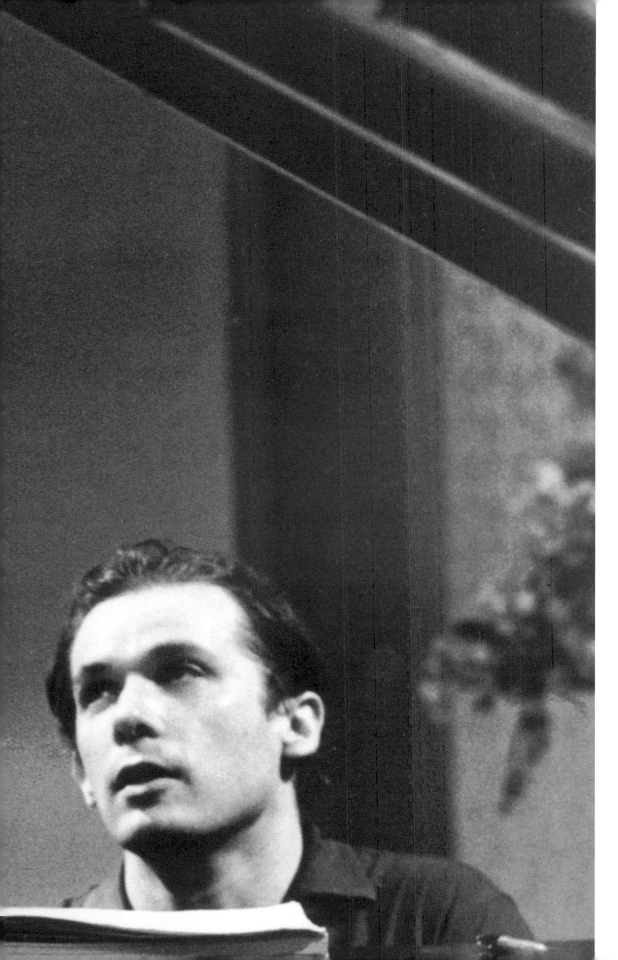

Duo. Gould was a great admirer of Yehudi Menuhin and welcomed the opportunity to play with him. In 1966 they performed together on television, first commenting on the pieces they played:

MENUHIN: We've had only a very short period together working on this Sonata in G Major by Beethoven.

GOULD: . . . Because I don't play that much chamber music, I had in mind a little bit of . . . the "pipe and peasant" aspect of Beethoven, the "quasi-militaristic" quality of the early period.

MENUHIN: Well, I was wondering, because at first you took certain liberties dynamically and in the phrasing of the lines. You were very strict rhythmically and then later on you became less strict rhythmically. Whether that was my bad influence—I hope not—but it was rather Romantic.

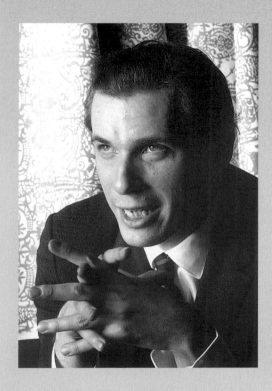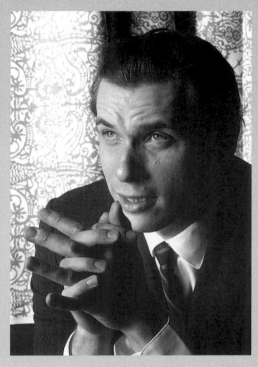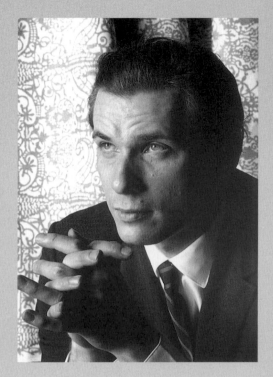

"Glenn was so much more than a talent. He studied; he thought. He was a profound musicologist. He had more understanding of what he was playing than 99 per cent of pianists when they play on the concert stage."

ROBERT SILVERMAN

"The most basic premise of Gould's aesthetic was that music is primarily mental and only secondarily physical. . . . For Gould a musical work was an abstract entity that could be fully comprehended in the mind in the absence of performance, without even the recollection of sounds or of physical means of production."

KEVIN BAZZANA

(ABOVE) From 1966. (OPPOSITE) From 1980.

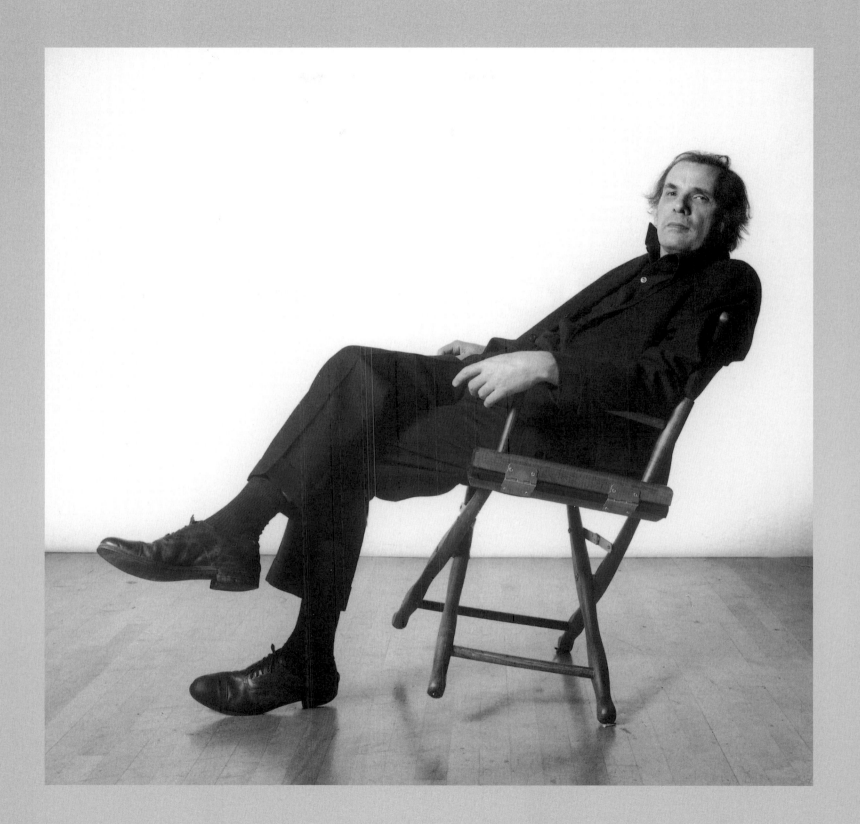

Producing and directing at the CBC. (OPPOSITE AND ABOVE LEFT) In the late 1960s, around the time of his first radio documentaries. (ABOVE RIGHT) With his sound equipment: "I've always been fascinated with the metrical things that one can do with the human voice, both writing for it and editing it . . . in terms of the documentaries that I prepare. That's why I guess I end up in a recording room doing about the most futile thing that anyone can do: conducting the human voice already in the can. One can't change its cadence, but one can change one's own reaction to its cadence and gain ideas from its cadence and prepare the next cadence of the next human voice. And that's why I find radio documentary especially so fascinating because one can make . . . a statement about the human condition by virtue of the way in which you can define it using the human voice."

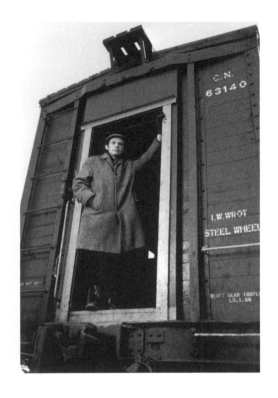

The Idea of North. To celebrate Canada's Centennial year, 1967, CBC Radio asked Gould to develop a special project on the Canadian North. The documentary was conceived as a new form, one in which the speakers' voices contrapuntally overlapped each other. "It's perfectly true that . . . not every word is going to be audible, but then by no means every syllable in the final fugue from Verdi's *Falstaff* is either. . . . I would like to think that these scenes can be listened to in very much the same way that you'd attend the *Falstaff* fugue." (LEFT) Heading north. (OPPOSITE) Glenn and five other eminent Canadians in a portrait for Canada's Centennial year; (left to right) Morley Callaghan, Ernest MacMillan, Kate Reid, A.Y. Jackson, Gould and Marshall McLuhan.

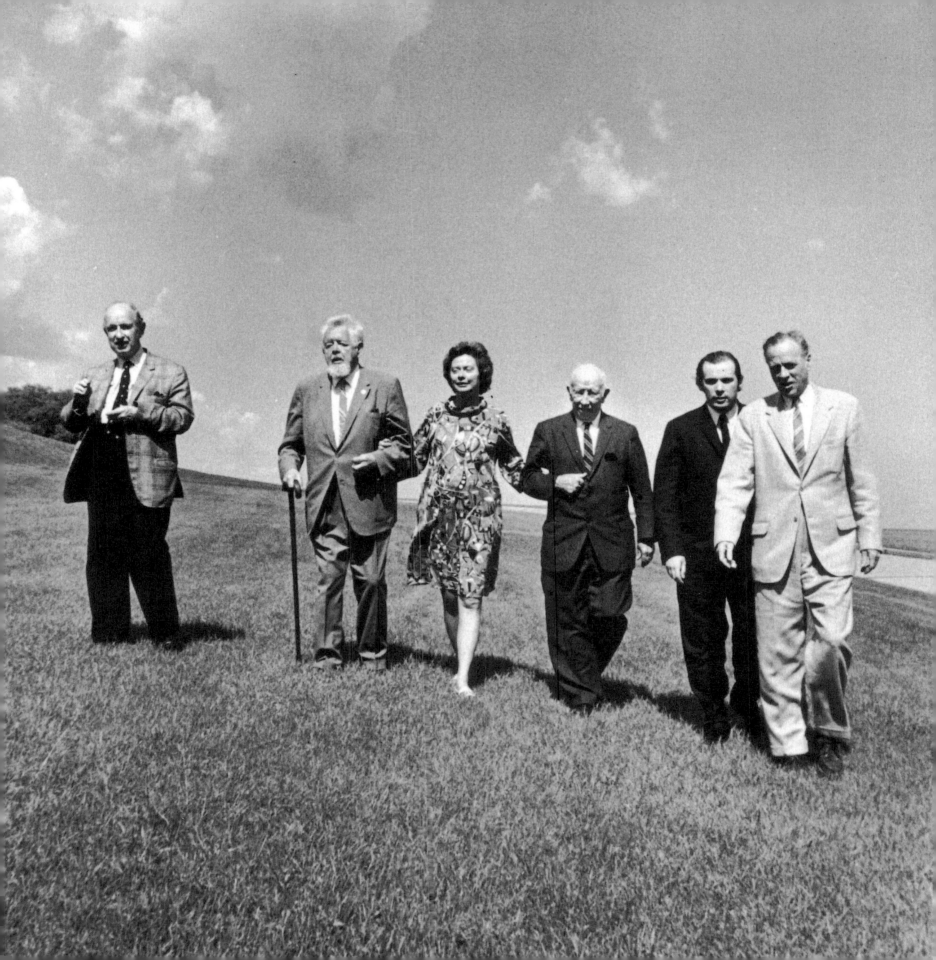

The Idea of North was "an opportunity to examine that condition of solitude which is neither exclusive to the north nor the prerogative of those who go north but which does, perhaps, appear . . . a bit more clearly to those who have made, if only in their imagination, the journey north."

GLENN GOULD

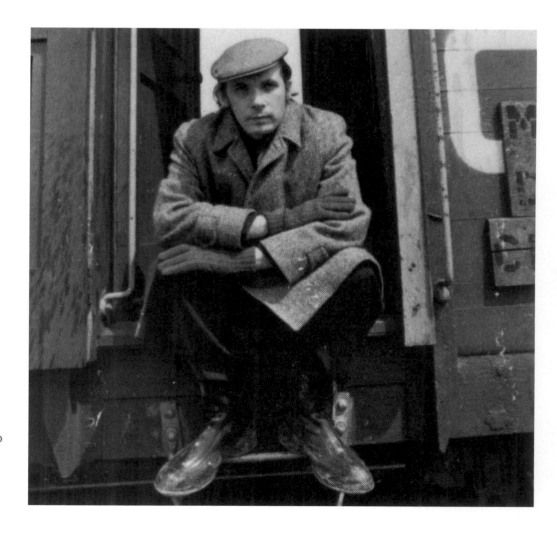

"A major theme of *The Idea of North* is existential human communion . . .

Gould's contrapuntal documentaries are . . . his greatest creations, the

realization of his desire to move from the world of performance to that

of 'composition.' It was with *The Idea of North* that Gould seriously

launched his new genre, and began his creative adventure."

HOWARD FINK

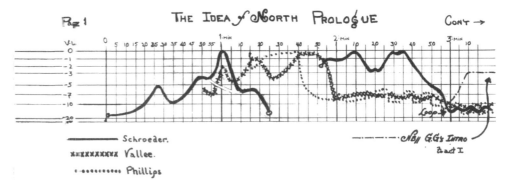

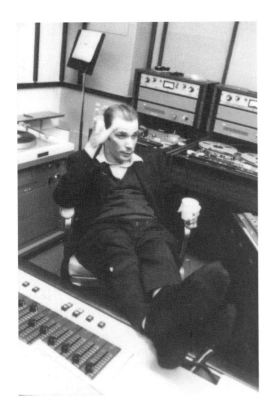

(LEFT) Listening to a playback of one of his radio documentaries. (ABOVE) Graph from *The Idea
of North*, prepared by Lorne Tulk, Gould's sound engineer. It illustrates the interweaving of three
voices in Gould's contrapuntal radio documentary.

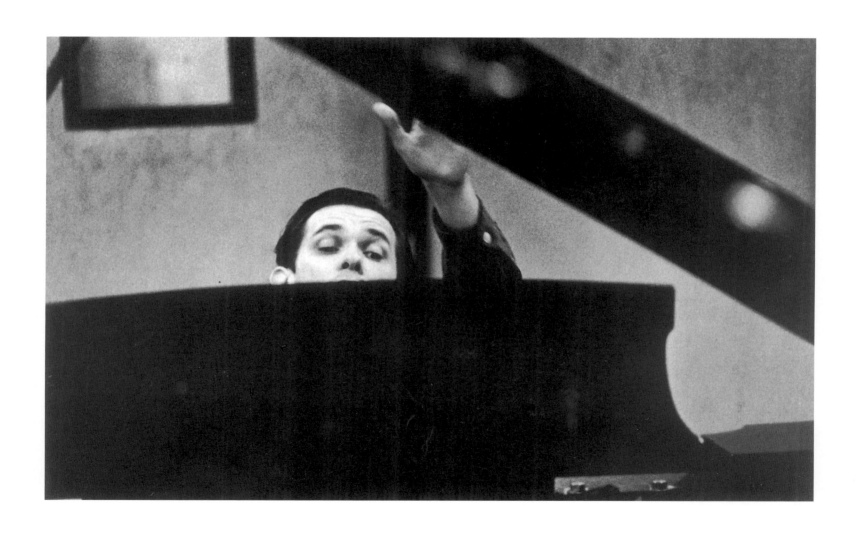

GLENN GOULD ❧ A Life in Pictures

Recording a Schoenberg song, Gould conducts Helen Vanni (off camera), 1965.

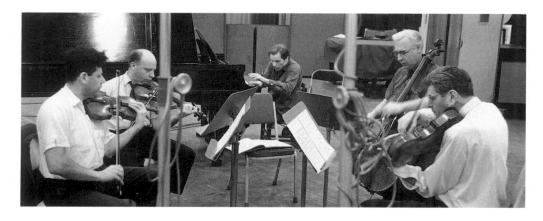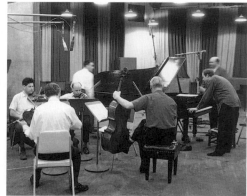

Recording Schoenberg's *Ode to Napoleon*, opus 4, with the Juilliard String Quartet, in February 1965. Gould had long championed Schoenberg and regarded his opus 4 as a milestone in twentieth-century music. It is "Schoenberg's most urgent plea on behalf of that cause for which he campaigned with increasing fervour . . . the co-existence of tonality and twelve-tone technique. . . . [The *Ode to Napoleon*] is one of those works that, for better or worse, has changed the course of music in the twentieth century."

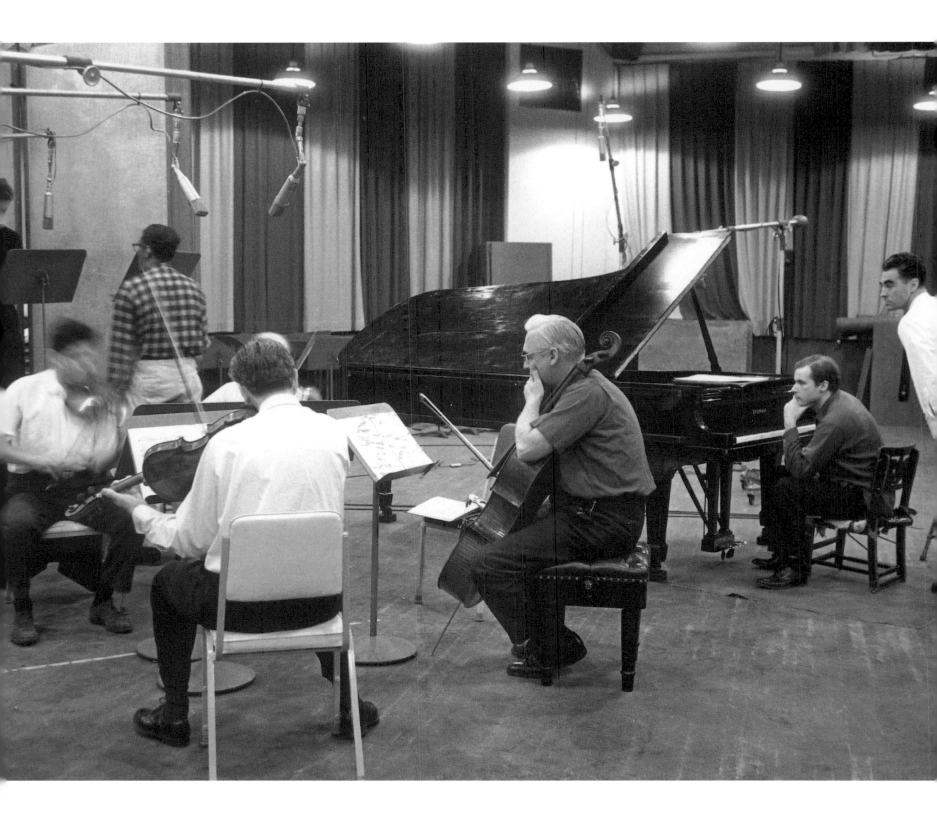

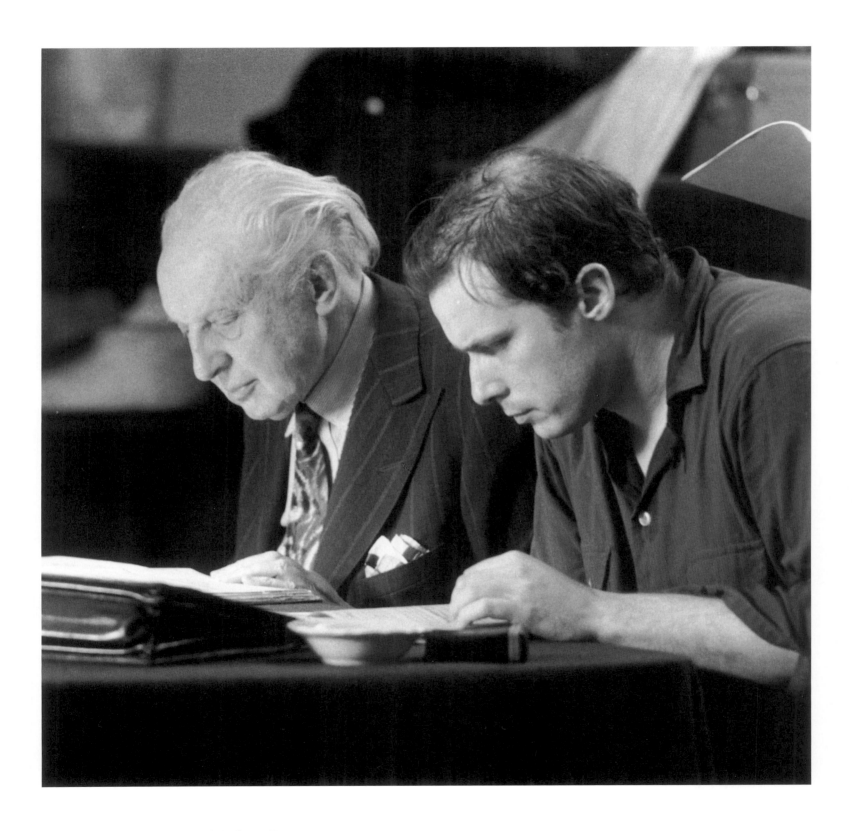

GLENN GOULD ✒ A Life in Pictures

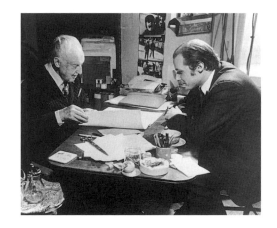

(OPPOSITE PAGE) With Leopold Stokowski, studying the score of Beethoven's *Emperor* Concerto during a recording date, March 1966. "'What is your tempo?' the Maestro inquired, as I settled in [at the piano]. 'My tempo is your tempo,' I responded in a bad imitation of Rudy Vallee. 'I hope, however,' I continued, rather courteously, 'that, whatever the tempo, we can make this piece into a symphony with piano obbligato; I really don't think it ought to be a virtuoso vehicle.' . . . [I was trying] to enlist his aid in an attempt to demythologize the virtuoso traditions which have gathered round this particular work." Later, Gould wrote: "Stokowski . . . refused to regard the score, or the material with which he had to work, as Holy Writ; for him it was rather like a collection of newly discovered parchments for gospel yet to be transcribed." Gould could have been describing himself. (LEFT) Interviewing Stokowski in 1969 in Stokowski's New York apartment for *Stokowski: A Portrait for Radio*, broadcast on the CBC in 1971.

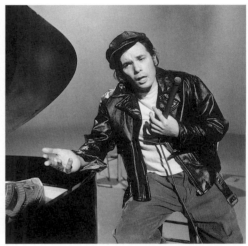

In character. Gould would often express his ideas on art and music (and his penchant for humour) by adopting different personas: (ABOVE LEFT) as Dr. Karlheinz Klopweisser, the noted German composer; (ABOVE RIGHT) as the Marlon Brando–like Myron Chianti (aka Theodore Slutz); and (OPPOSITE) as Sir Nigel Twitt-Thornwaite, a dotty British conductor.

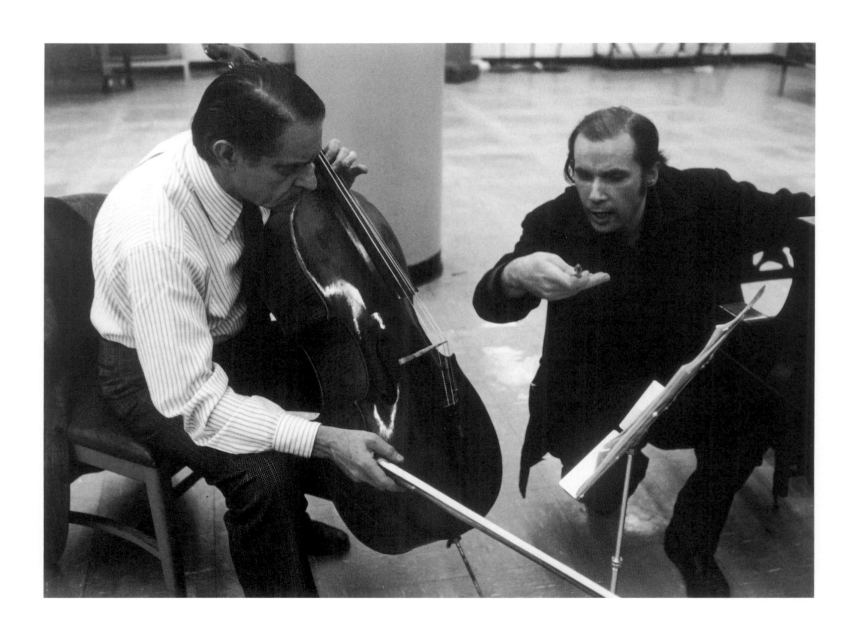

GLENN GOULD ✑ A Life in Pictures

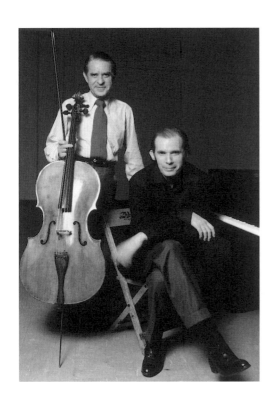

With cellist Leonard Rose, recording Bach sonatas for viola da gamba and keyboard, in late 1973.

"Glenn was probably one of the most individualistic artists I've ever heard . . . [he] was not a person who played particularly intuitively. Everything was highly thought out. . . . But he was simply capable of doing things where other great pianists would not dream of wandering so far afield."

LEONARD ROSE

Glenn Gould Interviews Glenn Gould on Glenn Gould.

glenn gould: Mr. Gould, I gather that you have a reputation as a—well, forgive me for being blunt, sir—but as a tough nut to crack, interview-wise?

GLENN GOULD: Really. I've never heard that.

g.g.: You've been quoted as saying your involvement with recording . . . represents an involvement in the future.

g.g.: That's correct . . .

g.g.: Quite so, and you've also said that . . . the concert hall . . . the opera house . . . represent . . . your own past in particular, perhaps as well as, in more general terms, music's past.

g.g.: That's true, although my only past professional contact with opera was a touch of tracheitis I picked up while playing at the old Festspielhaus in Salzburg.

g.g.: I [had] absolutely no idea as to the "aesthetic" merits of Karajan's Sibelius Fifth when I [first] encountered it. . . . In fact the beauty of the occasion was that, although I was aware of being witness to an intensely moving experience, I had no idea as to whether it was or was not a "good" performance. My aesthetic judgements were simply placed in cold storage. . . .

g.g.: Mr. Gould, are you saying you do not make aesthetic judgements?

g.g.: No . . . though I wish I were able to make that statement, because it would attest to a degree of spiritual perfection that I have not attained. However . . . I do try as best I can to make only moral judgements and not aesthetic ones—except . . . in the case of my own work.

Outside Canada, many were not aware of Gould's radio and television documentaries and tended to regard him as some kind of hermit. Gould cultivated this image of an isolated artist, particularly through the photographs taken of him for album covers.

These pictures, from a 1974 shoot with Columbia Records photographer Don Hunstein, were part of a series later used on the CD release of Sibelius's piano music.

"People ask if, as a photographer, I try to relate pictures to particular pieces of music. In the case of Glenn's albums, we were both concerned with creating a compelling image, without reference to a specific repertoire."

DON HUNSTEIN

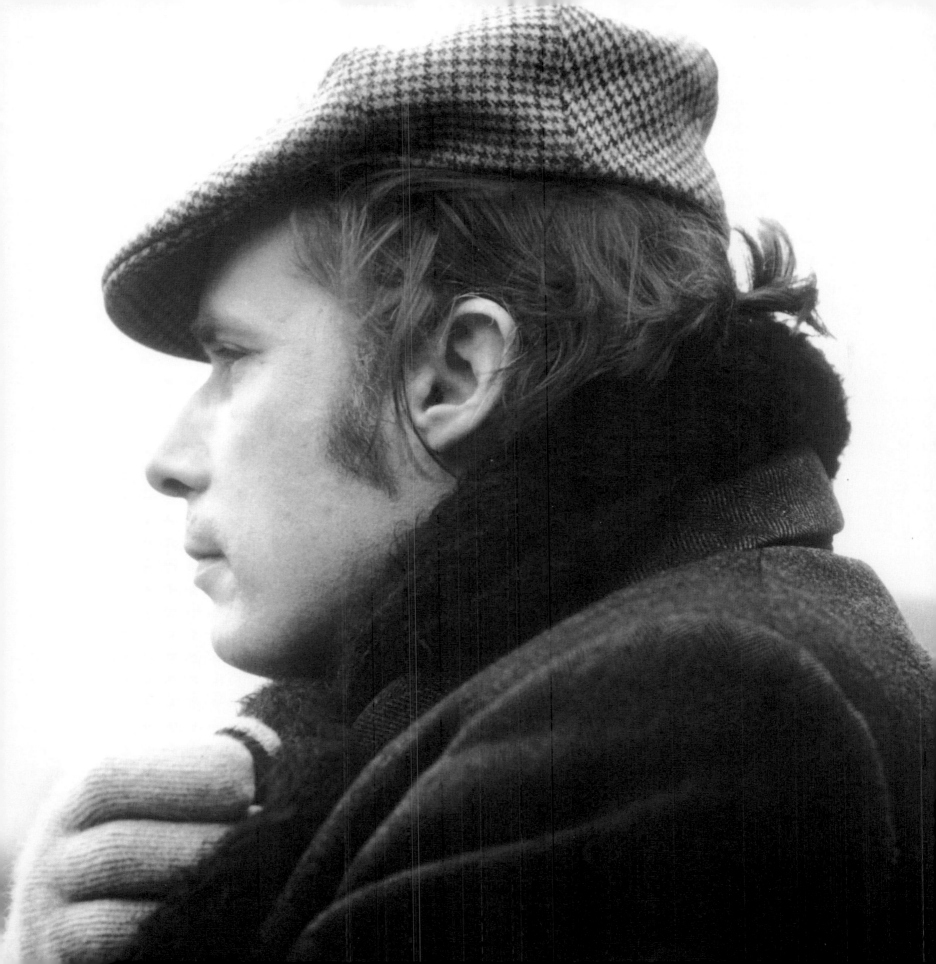

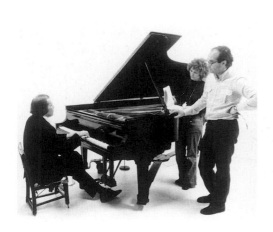

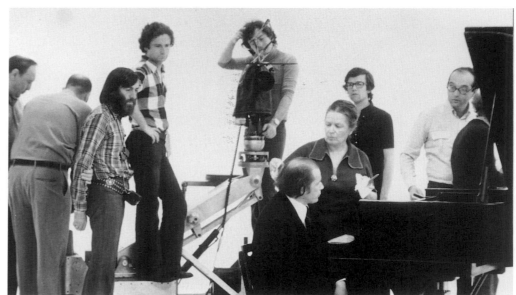

In 1974 filmmaker and violinist Bruno Monsaingeon shot a four-part series for French television in Toronto, *Les Chemins de la Musique*. Each part recapitulated different aspects of Glenn's life. Monsaingeon wrote that Gould "resisted the falsely satisfying temptations of the world: public opinion did not reach him; he did not seek approval . . . Indeed he thought the artist should be granted anonymity. In this quest, he was reaching back to the status of the Medieval illuminators and cathedral builders who served a purpose larger than themselves."

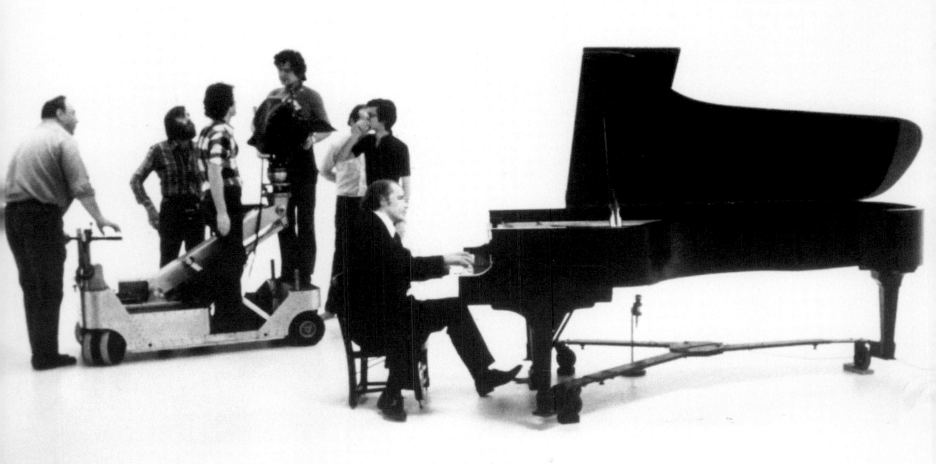

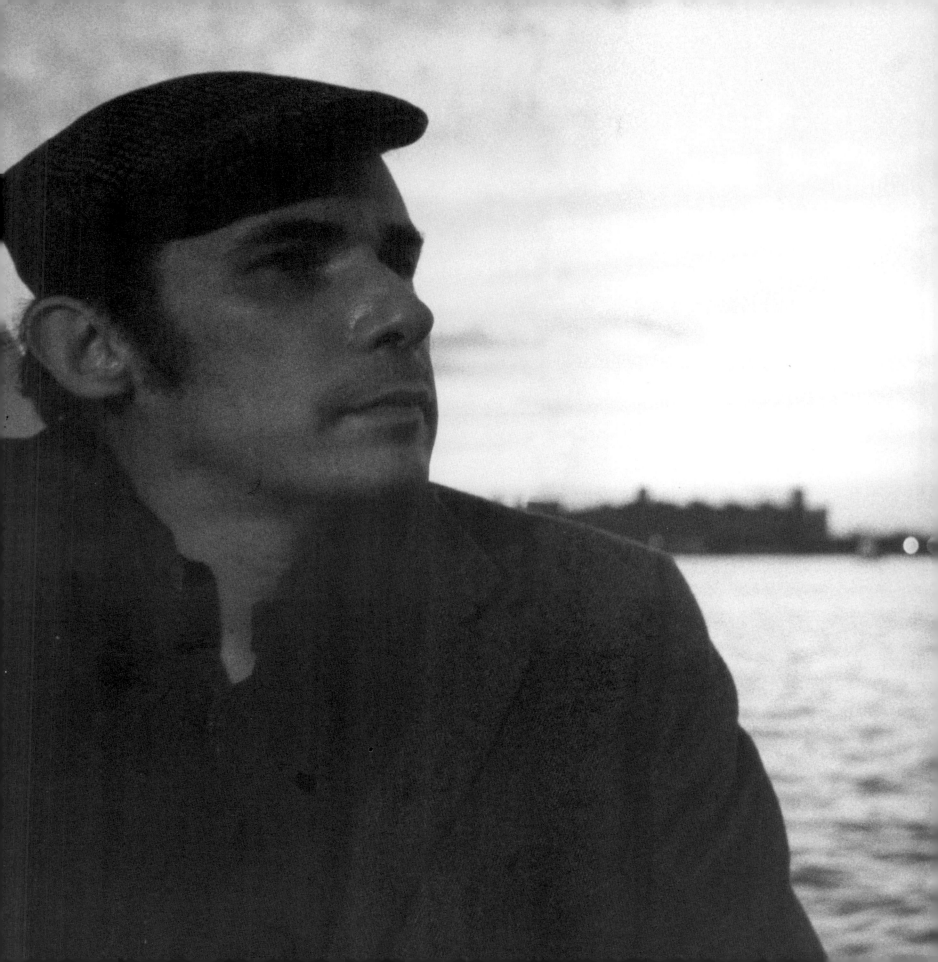

Home (1979). "Toronto does belong on a very short list of cities I've visited that seem to offer—to me at any rate—peace of mind—cities which, for want of a better definition, do not impose their 'cityness' on you.

"Toronto [has had a special] relationship with American cities to the south, such as Buffalo . . . forty miles across the lake. . . . In my youth . . . for a really lively weekend, what you had to do was drive to Buffalo. Nowadays . . . we still seem to have some deep-seated psychological need to look at Buffalo. . . . So, in 1976 we built the [CN] Tower . . . the tallest free-standing structure in the world . . . From up there, on a clear day, you can see, if not forever, at least to Buffalo.

"But perhaps I see [Toronto] through rose-coloured glasses; perhaps what I see is still so controlled by my memory that it's nothing more than a mirage. I hope not . . . because if that mirage were ever to evaporate, I should have no alternative but to leave town."

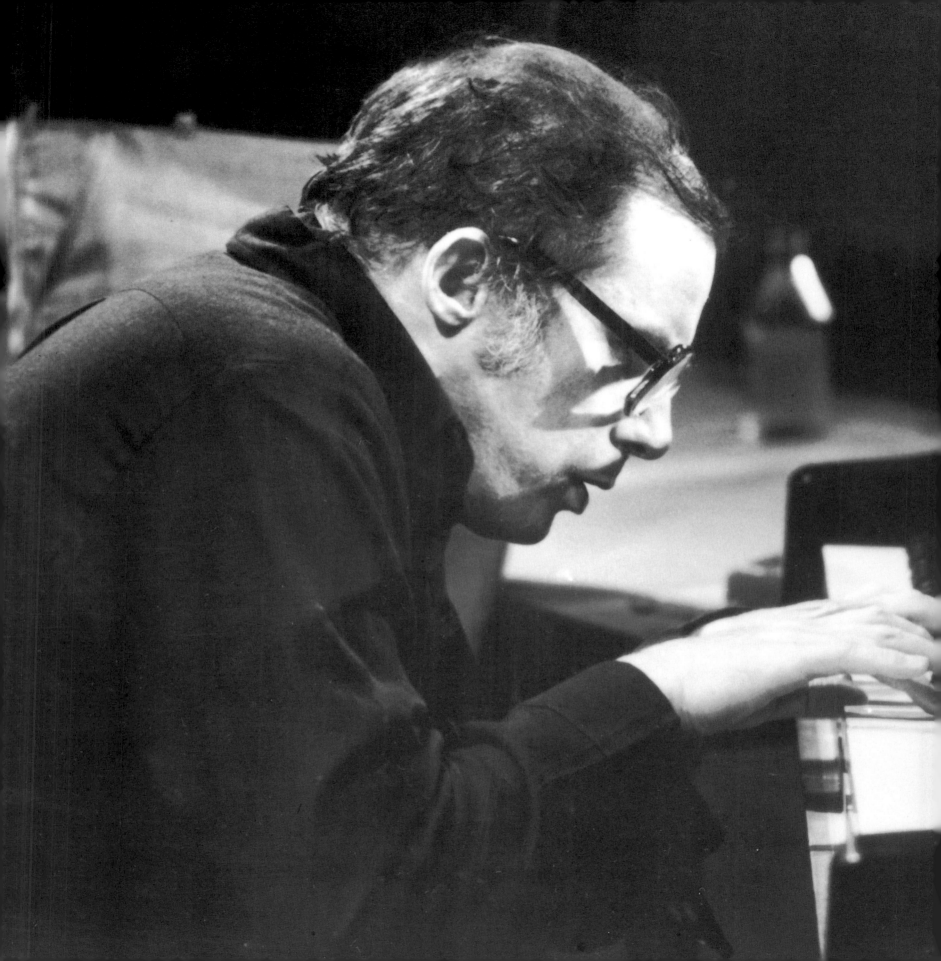

Gould launched his recording career with the *Goldberg Variations*. In 1981, some twenty-five years later, he decided to record it again. He wanted a purer interpretation, he said, "a way of making some sort of almost mathematical correspondence between the theme and subsequent variations. . . . " The purity of his interpretation, the anguished poignancy of his playing in the slower passages, suggest someone "determined to impose, aesthetically and emotionally, his sensibility on his listeners. And he was saying 'Good-bye.' And this was such an exquisite way of doing it." (John McGreevy)

The record was released in September 1982. A few weeks later, he died.

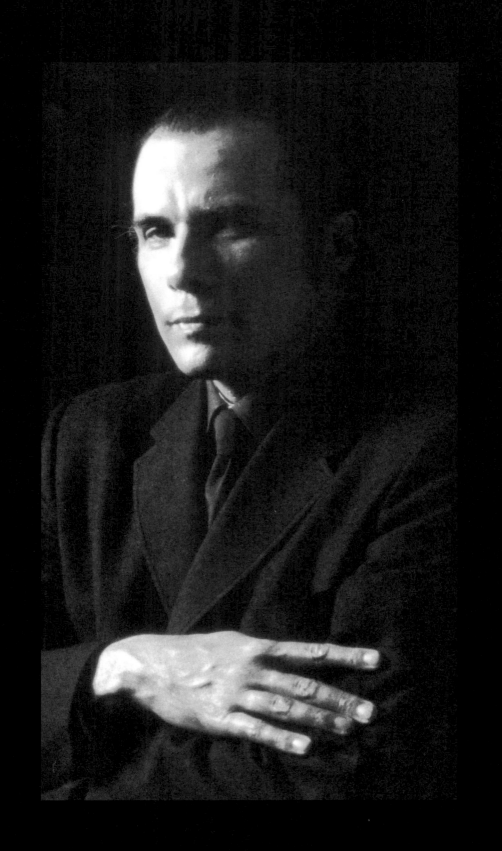

ENVOI

The Last Puritan.

Farewell. Gould suffered a stroke on September 27, 1982, just two days after his fiftieth birthday. A blood clot was discovered in his brain. After several days in hospital, he lost consciousness. Brain damage was massive. A week after he was admitted, he was taken off life support. On October 4, 1982, he was pronounced dead.

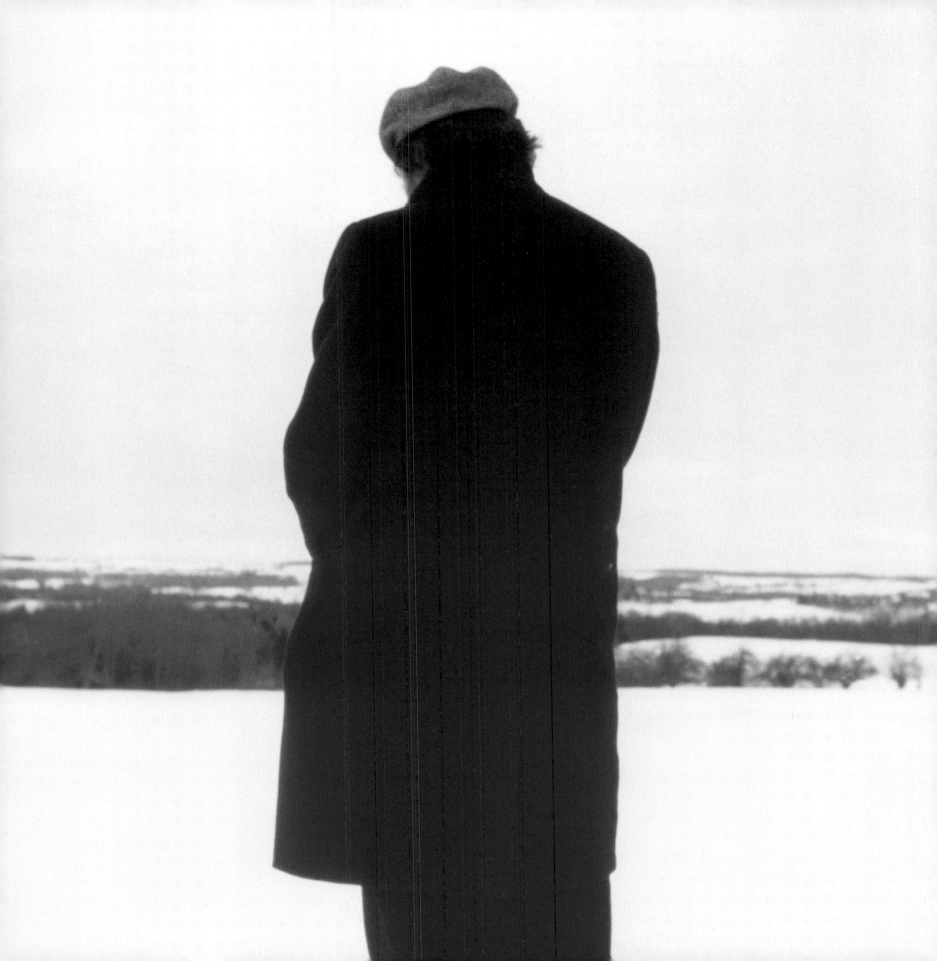

Absence. (OPPOSITE) Gould's desk in his studio at the Inn on the Park, Toronto. (RIGHT) Two views of his mixing board at the Inn on the Park studio. These photos were taken after his death and show his workspace as he left it.

Silence. Inside Gould's midtown apartment after his death. (LEFT) His telephone stand. (BELOW) The storage area in his apartment. (OPPOSITE) The now silent piano.

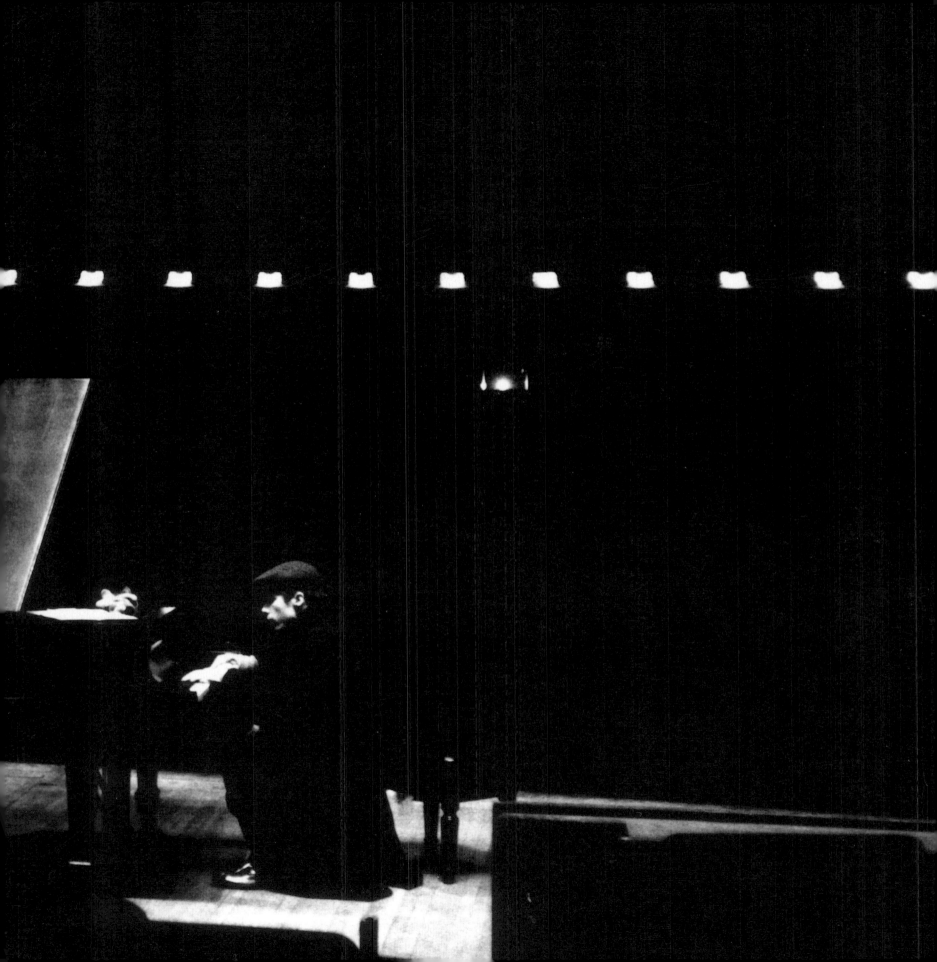

CHRONOLOGY

Glenn Gould
(1932–1982)

1932	Glenn Herbert Gold is born in Toronto on September 25, to Florence Gold (née Greig) and Russell Herbert (Bert) Gold. (The family name was changed to Gould in 1938.)
c. 1935	Begins piano studies with his mother, who continues as his teacher for the next eight years.
1940	Achieves first-class honours in Grade 4 piano at the Toronto Conservatory of Music.
1940–47	Studies theory with Leo Smith.
1942–49	Studies organ with Frederick Silvester.
1943–52	Studies piano with Alberto Guerrero.
1944	Wins first prize (a $200 scholarship) at the first Kiwanis Music Festival.
1945	Begins high school at Malvern Collegiate Institute, Toronto.
	Gives first professional performance, on the organ, at Eaton Auditorium, Toronto (December 12).
1946	Orchestral debut, with the Toronto Conservatory Orchestra at Massey Hall (May 8). Gould plays the first movement of Beethoven's Piano Concerto No. 4.
	Graduates with honours from the Toronto Conservatory of Music.
1947	Debuts with the Toronto Symphony at Massey Hall (January 14). Gould plays the entire Beethoven Piano Concerto No. 4.
	Gives first professional piano recital, Eaton Auditorium (October 20).
1948	Writes a piano sonata, his first major composition.
1950	Gives first recital on CBC Radio (December 24).
1951	Tours western Canada. Debuts with the Vancouver Symphony (October 28), followed by a recital in Calgary (November 7).
1952	Debuts on CBC Television as the first pianist in Canada to be televised live (September 8).
1953	Records commercially for the first time, on the Hallmark label.
	First concert appearance at the Stratford (Ontario) Festival (July 31).

1954 Performs his *Cadenzas* to Beethoven's Piano Concerto No. 1 in his debut with the Montreal Symphony (December 14).

1955 United States debut, in recital at the Phillips Gallery, Washington, D.C. (January 2).

New York debut at Town Hall (January 11).

The next day he signs an exclusive recording contract with Columbia Records.

Records Bach's *Goldberg Variations* for Columbia Records.

1956 Composes his String Quartet, opus 1.

Debut recording for Columbia is released.

Tours Canada and the United States.

Debuts with the St. Louis Symphony, conducted by Vladimir Golschmann (December 29). Golschmann would later be the conductor on many of Gould's recordings.

Becomes, with Oscar Shumsky and Leonard Rose, director of music at the Stratford (Ontario) Shakespearean Festival.

1957 Debuts with the New York Philharmonic at Carnegie Hall with Leonard Bernstein conducting Beethoven's Piano Concerto No. 2 (January 26).

Tours the Soviet Union, West Germany and Austria. Plays with the Leningrad Symphony and with the Berlin Philharmonic under Herbert von Karajan.

Records the Beethoven Piano Concerto No. 2 with Leonard Bernstein and the Columbia Symphony.

1958 Second overseas tour—Austria, Sweden, West Germany, Italy and Israel.

Records Beethoven's Piano Concerto No. 1 with Vladimir Golschmann.

1959 Performs a cycle of Beethoven piano concertos with the London Symphony (May 20–June 1).

Gives his last European performance, in Lucerne, Switzerland (August 31).

1959–60 Records the Brahms Intermezzi.

1960 Makes his first American television appearance, with Leonard Bernstein and the New York Philharmonic (January 31).

Is the subject of two documentary films released by the National Film Board of Canada— *Glenn Gould: On the Record* and *Glenn Gould: Off the Record*.

Steinway No. CD 318 becomes Gould's favourite piano after he discovers it at Eaton Auditorium.

1961	Records Schoenberg's Piano Concerto, with Robert Craft conducting the CBC Symphony.
1962	Produces the first of a series of music documentaries for the CBC, *Arnold Schoenberg: The Man Who Changed Music* (CBC Radio, August 8), and later, *Richard Strauss: A Personal View* (CBC Television, October 15).
	Performs Brahms's Piano Concerto No. 1 with Leonard Bernstein and the New York Philharmonic (April 6 and 8). Bernstein publicly takes issue with Gould's interpretation.
	Records Bach's *The Well-Tempered Clavier*, Book 1, Nos. 1–8.
1963	Composes "So You Want to Write a Fugue?" for the CBC-TV broadcast of Gould's *The Anatomy of the Fugue* (March 4).
	Delivers the Corbett Music Lecture, "Arnold Schoenberg: A Perspective," at the University of Cincinnati (April 22) and the MacMillan Lectures at the University of Toronto (July).
	Columbia releases his recording of the Bach Partitas.
1964	Performs publicly for the last time, in Los Angeles (April 10).
	Receives a Doctor of Laws degree from the University of Toronto and delivers the convocation address, "Music in the Electronic Age" (June 1).
	Records Schoenberg's "Book of the Hanging Gardens," with Helen Vanni.
1965	Broadcasts on CBC Radio "The Prospects of Recording" (January 10).
	Records Schoenberg's *Ode to Napoleon*, with the Juilliard String Quartet.
1966	*Duo*, with Yehudi Menuhin, is broadcast on CBC-TV (May 18).
	Appears in the first of a series of radio programs called *The Art of Glenn Gould* (November 13), which continues through 1967. Gould discusses his recordings and other musical matters.
	Records Beethoven's Piano Concerto No. 5 (the *Emperor*), with Leopold Stokowski.
1967	*The Idea of North*, the first of Gould's three contrapuntal radio documentaries on solitude, is broadcast on CBC (December 28).
	Records Prokofiev's Sonata No. 7 in B-flat Major.
1968	Is awarded the Canada Council Molson Prize ($15,000), for outstanding achievement in the arts.

1969 The second series in *The Art of Glenn Gould* is broadcast on CBC Radio
 (May 18–October 15).

 CBC broadcasts the second of his radio programs on solitude, *The Latecomers*
 (November 12).

 Records Bach's *The Well-Tempered Clavier*, Book II, Nos. 17–24.

1970 CBC Television program *The Well-Tempered Listener*. Gould discusses the continuing
 appeal of Bach and performs on piano, harpsichord and organ (February 3).

 Television version of *The Idea of North*, CBC-TV (August 5).

1971 Produces *Stokowski: A Portrait for Radio* for CBC (February 2).

 Records Grieg's Piano Sonata in E Minor.

1972 Arranges the music for the film *Slaughterhouse-Five*, based on the Kurt Vonnegut novel.

 Records Bach's French Suites.

1973 Purchases Steinway CD 318.

 Records his piano transcription of Wagner's "Siegfried Idyll."

1974 Creates, with Bruno Monsaingeon, a series of four television programs, *Les Chemins de la
 Musique*, for French television.

 Produces for CBC *Casals: A Portrait for Radio* (January 15).

 Produces for CBC-TV "The Age of Ecstasy: Music from 1900 to 1910," the first of a
 four-part series called *Music in Our Time* (February 20).

 Produces for CBC Radio *Arnold Schoenberg: The First Hundred Years* (November 19).

 Records Bach's Sonata for Viola da Gamba and Keyboard No. 1 in G Major with
 Leonard Rose.

1975 CBC-TV broadcasts Gould's "The Flight from Order: Music from 1910 to 1920"
 (February 5).

 Florence Gould dies on July 26.

 CBC-TV broadcasts Gould's "New Faces, Old Forms: Music from 1920 to 1930"
 (November 26).

 Records Bach's Sonatas for Violin and Harpsichord with Jaime Laredo.

1977	CBC Radio broadcasts the third of Gould's solitude trilogy, *The Quiet in the Land* (March 25).
	CBC-TV broadcasts Gould's "The Artist as Artisan: Music from 1930 to 1940" (December 14).
	Records Sibelius's Three Lyric Pieces for Piano.
1979	CBC Radio broadcasts Gould's *Strauss: The Bourgeois Hero* (April 2 and 9).
	CBC-TV broadcasts "Glenn Gould's Toronto," part of the *Cities* series (September 27).
	Glenn Gould Plays Bach, No. 1: The Question of Instrument, a Clasart film directed by Bruno Monsaingeon, is released.
	Records Strauss's Five Piano Pieces, op. 3.
	Records Beethoven's Piano Sonata No. 15 in D Major ("Pastoral").
1980	CBS Records issues a two-record set, *Glenn Gould Silver Jubilee Album*.
	Glenn Gould Plays Bach, No. 2: The Art of the Fugue is released by Clasart.
	Records Haydn's Sonatas Nos. 60 and 61.
1981	Records Haydn Sonatas Nos. 56, 58, 59 and 62.
1982	CBS issues Gould's second recording of the *Goldberg Variations*. (The video version had been released in 1981 by Clasart.) The following year, the album wins two Grammy awards and a Juno.
	Arranges the music for *The Wars*, a film based on the novel by Timothy Findley.
	Records Brahm's Ballades, Op. 10. Released posthumously in 1983.
	Final recording: Gould conducts a chamber version (for 13 instruments) of Wagner's "Siegfried Idyll." Columbia releases it posthumously in 1990.
	Suffers the first of several strokes on September 27.
	Glenn Gould dies on October 4, at Toronto General Hospital.

I met Glenn Gould only once. It was in 1979, at a screening of "Glenn Gould's Toronto," part of the *Cities* television series. Lester & Orpen Dennys was publishing the book based on the series. He called me several times after that to discuss the editing of his script for the book—particularly, as I recall, the circumstances that dictate the use of a semi-colon versus a comma.

Three years later, while at the Frankfurt Book Fair, I learned of his death. I felt shock, sadness and the sense that we had lost not only Glenn Gould, but that the vital effect he had on our collective lives was also gone. This book is being published on the 20th anniversary of his death (and the 70th of his birth). Glenn Gould was an artist of deep conviction and humanity. The book. I hope, pays tribute to that, and to the unique creative presence that was Glenn Gould.

ACKNOWLEDGEMENTS

Publishing is a collaborative process, and a book of photographs like this one involves the talent, resources and assistance of a great many organizations and individuals. Special thanks are due to:

—The Estate of Glenn Gould, and to its executor, Stephen Posen, who first conceived of the idea for this book, and to Ray Roberts and David Ullmann:

—Doubleday Canada, and to Meg Taylor, the book's editor. Maya Mavjee, publisher, Scott Richardson, designer, and Carla Kean, production coordinator;

—The Glenn Gould Foundation, and to John Miller, Executive Director, and Kevin Bazzana, Editor of its journal, *GlennGould*;

—Sony Classical, and to Faye Perkins, Vice President of International Marketing, Esther Won, and Robert Baum;

—The National Library of Canada, and to Timothy Maloney, Director, Music Division, and Maureen Nevins, music archivist;

—The CBC, and to Lynda Barnett, design librarian

Finally, very special thanks to my associate, Andrea Knight, whose help in putting this book together was invaluable, and who, in addition, so effectively and efficiently organized the myriad of details of the photo permissions.

MALCOLM LESTER

The two important biographies of Glenn Gould are *Glenn Gould: A Life and Variations* by Otto Friedrich and *Glenn Gould: The Ecstasy and Tragedy of Genius* by Peter Ostwald. *Glenn Gould at Work: Creative Lying* by Andrew Kazdin, *Virtuoso* by Harvey Sachs, *The Great Pianists* by Harold C. Schonberg and *Best Seat in the House* by Robert Fulford also contain valuable information on Gould's life and music. *Glenn Gould Variations*, edited by John McGreevy, contains pieces by Dennis Dutton, Leonard Bernstein and Bruno Monsaingeon, as well as the fascinating *New Yorker* profile "Apollonian" by Joseph Roddy; *The Idea of Gould* by Rhona Bergman contains interviews with Don Hunstein and Robert Silverman. Glenn Gould's own essays and radio and television scripts can be found in *The Glenn Gould Reader*, edited by Tim Page, and *The Art of Glenn Gould: Reflections of a Musical Genius*, edited by John P. L. Roberts. Roberts, along with Ghyslaine Guertin, also edited *Glenn Gould: Selected Letters*. *Glenn Gould: The Performer in the Work* by Kevin Bazzana and *Glenn Gould: Music and Mind* by Geoffrey Payzant provide more analytical views of Gould's artistry.

Gould's "Notes for an Obituary of Florence Gould" is found at the National Library of Canada, as is his amusing and self-deprecating biographical essay, which first appeared in the July 17, 1956 issue of *Weekend* magazine. Jessie Greig's reminiscences of her cousin are from the October 1986 issue of the *Bulletin of the Glenn Gould Society*, and Angela Addison's comments, from its October 1988 issue.

GlennGould magazine is a source of richly informative articles on all aspects of Gould's career. Particularly helpful were the Spring 2001 issue with its account of Gould's Russian tour, and the Fall 1997 issue dealing with *The Idea Of North*. Gould's liner notes for the CBC album *Glenn Gould's Solitude Trilogy* amplify his vision of the North and solitude.

There are many excellent videos of Gould speaking and playing. Noteworthy are *Glenn Gould: Two Portraits of the Celebrated Pianist*, the multi-part series *The Glenn Gould Collection*, *Glenn Gould: A Portrait* and *Glenn Gould: Shadow Genius*, from which the Peter Elyakim Taussig quote is taken.

Finally, special mention must be made of the exhaustive Glenn Gould *Chronology* by Ruth Pincoe at the National Library of Canada. The *Chronology* was of inestimable help in identifying many of the performances and recordings depicted in the pictures.

Every effort has been made to contact copyright holders. In the event of omission or error, please notify Malcolm Lester & Associates, 50 Prince Arthur Avenue, Suite 605, Toronto, Canada M5R 1B5.

Some agency and archive names have been abbreviated in this source list:

CBC: Canadian Broadcasting Corporation, Still Photo Collection, Toronto

GGE: Estate of Glenn Gould

SC: Sony Classical

SFC: Stratford Festival of Canada

Cover, Endpapers, Front matter and Colophon front cover, back cover and endpapers: GGE; front matter: p. 1 GGE; pp. 2–3 Dan Weiner. Courtesy of Sandra Weiner; pp. 4–5 Gaby. Courtesy of the Gaby Estate; pp. 6–9 Don Hunstein, SC; p. 10 GGE; pp. 11, 15 SC; pp. 17, 18, 20, 22 (top) GGE; p. 22 (bottom) SC; p. 25 Norman James, Toronto Star; pp. 26, 28 GGE; p. 31 CBC; p. 32 SC; p. 35 GGE; p. 36 Courtesy of Margaret Pascu; p. 38 SC; p. 41 GGE; colophon: p.192 Donald McKague, GGE.

Part I pp. 42–63 GGE; p. 64: duBois Rembrandt, GGE; pp. 65–68 (left) GGE; p. 68 (right) Gordon W. Powley, GGE; pp. 69–70 GGE; p. 71 Gordon W. Powley, GGE; p. 72 (top): GGE; p. 72 (bottom) Brightling, GGE; p. 73 GGE.

Part II p. 74 Henri Rossier, SFC; pp. 76–77 Paul Rockett; pp. 78–81 Dan Weiner. Courtesy of Sandra Weiner; p. 82 Paul Weber, GGE; p. 83 (top) GGE; p. 83 (centre) Isaac Berez, GGE; p. 83 (bottom) J.H. Heslop, Deseret News; p. 84 Robert Ragsdale; p. 85 Don Hunstein, SC; pp. 86–87 GGE; p. 88 Paul Rockett; p. 89 Dan Weiner. Courtesy of Sandra Weiner; pp. 90–91 (top and centre) GGE; pp. 91 (bottom)–93 E. I. Ivano, GGE; pp. 94–95 J.M. Heslop, Deseret News; pp. 96–99 Don Hunstein, SC; p. 100 Fednews, GGE; pp. 101–105 GGE; p. 106 Paul Rockett; p. 107 (left and centre) GGE; pp. 107 (right)–109 Don Hunstein, SC; pp. 110–11 Herb Nott, SFC; p. 112 (left) Henri Rossier, SFC; p. 112 (right) SFC; p. 113 James R. Murray, SFC; pp. 114–23 Don Hunstein, SC; p. 124–25 Roy Martin, CBC; pp. 126–28 Dale Barnes, CBC; p. 129 (left and centre) Roy Martin, CBC; p. 129 (right) Dale Barnes, CBC; p. 130–31 Don Hunstein, SC.

Part III p. 132 Don Hunstein, SC; p. 134 (left) Jack Marshall, University of Toronto; pp. 134–35 Paul Rockett, University of Toronto; p. 136 (left) Fednews, GGE; p. 136 (right) Herb Nott, CBC; p. 137–39 Don Hunstein, SC; pp. 140–41 Albert Crookshank, CBC; pp. 142–43 John Kurland; pp. 144–45 CBC; p. 146 Hank Parker, SC; p. 147 Don Hunstein, SC; p. 148–49 (left) Herb Nott, CBC; 149 (right) CBC; 150 Harold Whyte, CBC; p. 151 Toronto Sun; p. 152 Harold Whyte, CBC; p. 153 (left) Herb Nott, CBC; p. 153 (right) GGE; pp. 154–55 W. Eugene Smith; pp. 156–58 Don Hunstein, SC; p. 159 CBC; pp. 160–61 Robert Ragsdale, CBC; pp. 162–67 Don Hunstein, SC; pp. 168—71 GGE; pp. 172–73 Don Hunstein, SC.

Part IV p. 174 GGE; pp. 176–77 Don Hunstein, SC; pp. 178–83 GGE.

PERMISSIONS

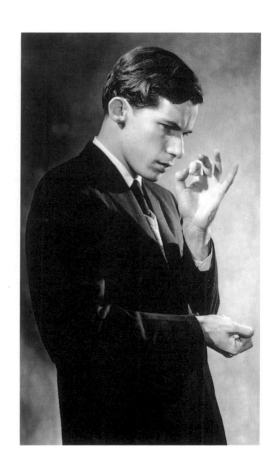

A NOTE ABOUT THE TYPE

The text, captions and quotations in *Glenn Gould: A Life in Pictures* are set in varying fonts from the Bauer Bodoni type family. Originally cut by the Italian type master Giambattista Bodoni circa 1767 and recut by the Monotype Corporation in the mid-1920s, the Bauer edition of the classic Bodoni represents a modern digital adaptation of one of Europe's oldest and most enduring typefaces. Its strength as a book face, like the power of a Bach orchestration, lies in subtle variations of weight and serif incorporated across a wide variety of forms and sizes, thereby allowing an elegant whole to be built of many seemingly disparate parts.

GLENN GOULD: A LIFE IN PICTURES

This book was created and developed by Malcolm Lester
Publisher Maya Mavjee
Editor Meg Taylor
Research and Permissions Andrea Knight
Design CS Richardson
Compositing and Production Management Carla Kean
Scanning and Image Enhancement Quadratone Graphics
Printing and Bindery Friesens